BUILDING BRILLIANT WATERCOLORS

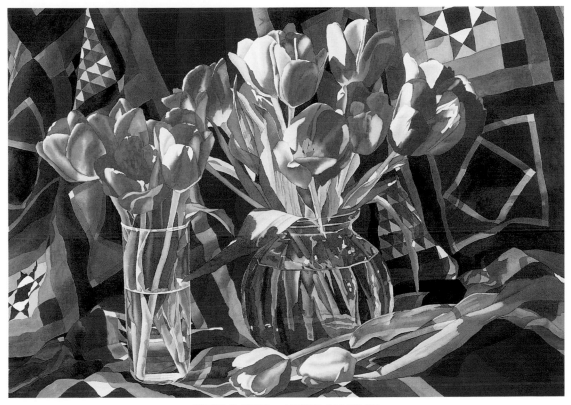

SIMPLE JOYS— AMISH SAMPLER

27½″ × 39″ (69.9cm × 99.1cm)

Collection of the artist.

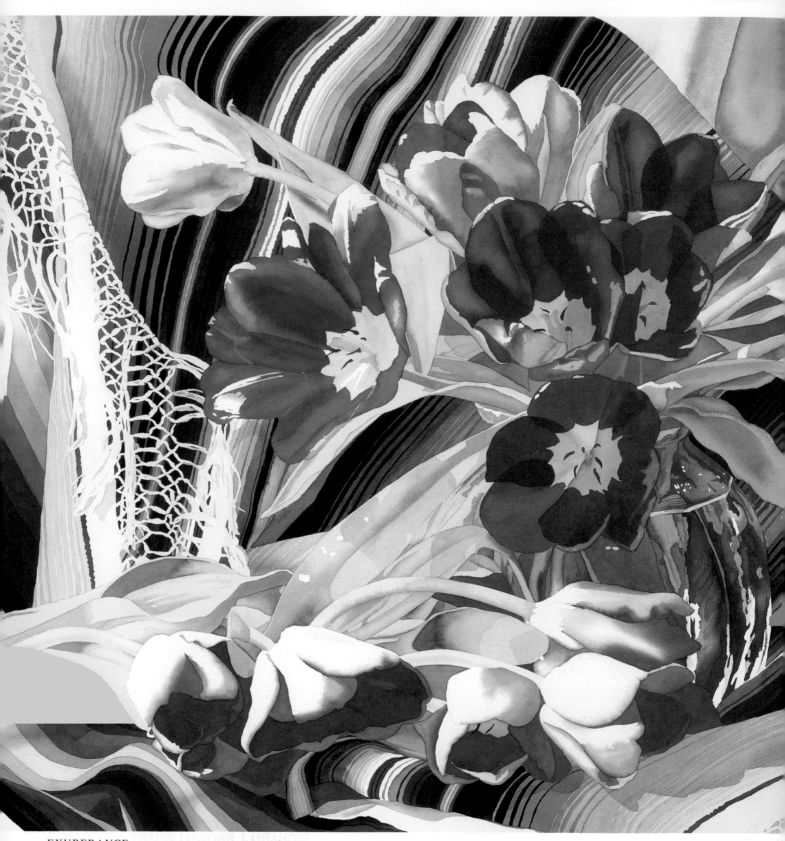

EXUBERANCE
39″ × 59″ (99.1cm × 149.9cm)
Collection of the artist.

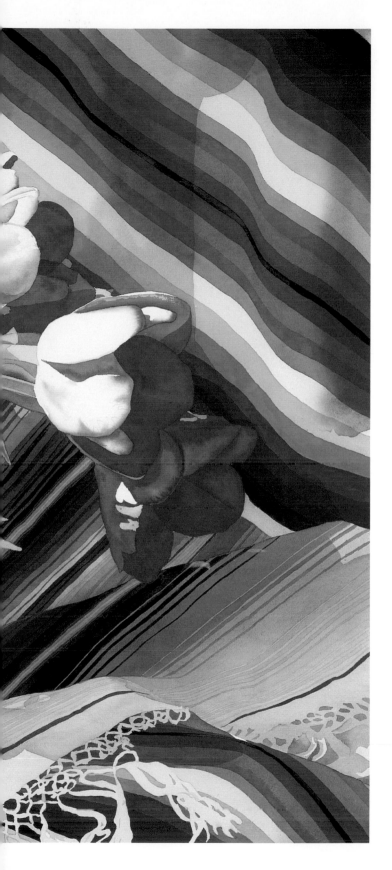

BUILDING
Brilliant
Watercolors

JUDY D. TREMAN

NORTH LIGHT BOOKS
CINCINNATI, OHIO

Judy D. Treman finds color and inspiration aplenty living in her hometown of Walla Walla, Washington. With a college minor in art, she discovered watercolor in 1978, and her use of color gradually evolved.

Treman has earned signature membership in the National Watercolor Society, Watercolor USA Honor Society, Watercolor West and the Northwest Watercolor Society. Her large-scale, colorful, detailed watercolors are widely represented in private, public and corporate collections, as well as being selected for national exhibitions including National Academy of Design, American Watercolor Society, Rocky Mountain Watermedia, Butler Institute of American Art and Allied Artists of America.

Treman's paintings are included in *Splash 3: Ideas and Inspirations*, *Splash 4: The Splendor of Light*, *Splash 5: The Glory of Color*, and *Basic Flower Painting Techniques* (all from North Light Books). Her paintings also appear in *Transparent Watercolor Wheel*, *The Best of Watercolor: Painting Color* and *The Best of Watercolor: Painting Composition*. Articles about her work appear in *The Artist's Magazine* (cover articles 1989 and 1994), *Watercolor Magic*, *Southwest Art Magazine*, *American Artist* and *Watercolor '90*.

Treman shares techniques she has developed through her "Building Brilliant Watercolors" workshops. (For more information about workshops, contact Judy at 1981 Russell Creek Road, Walla Walla, WA 99362.)

PHOTO BY ROSS MULHAUSEN

Building Brilliant Watercolors. Copyright © 1998 by Judy D. Treman. Manufactured in China. All rights reserved. No part of this book may be reproduced in any form or by any electronic or mechanical means including information storage and retrieval systems without permission in writing from the publisher, except by a reviewer, who may quote brief passages in a review. Published by North Light Books, an imprint of F&W Publications, Inc., 1507 Dana Avenue, Cincinnati, Ohio 45207. (800) 289-0963. First edition.

Other fine North Light Books are available from your local bookstore, art supply store or direct from the publisher.

03 02 01 00 99 5 4 3 2 1

Library of Congress Cataloging-in-Publication Data

Treman, Judy D.
 Building brilliant watercolors / Judy D. Treman
 p. cm.
 Includes index.
 ISBN 0-89134-839-5 (hardcover)
 1. Watercolor painting—Technique. I. Title.
ND2420.T74 1998
751.42′2—dc21 98-7302
 CIP

Edited by Jennifer Lepore and Pamela Seyring
Production Edited by Michelle Kramer
Designed by Brian Roeth

KALEIDOSCOPE
IN RED, WHITE
AND BLUE
38½″ × 27½″
(97.8cm × 69.9cm)
Private collection.

DEDICATION

To capturing the spirit of joy in each day. That is what color is all about. To my husband, Paul, who brings me the greatest joy.

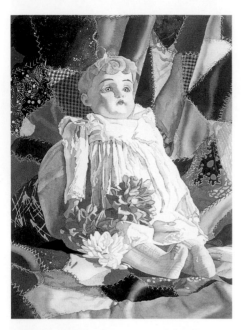

Introduction:
How Watercolor Captured My Heart... *8*

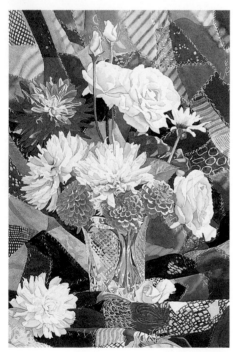

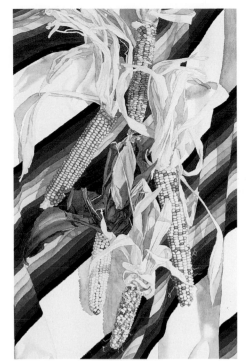

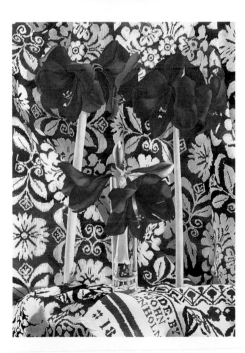

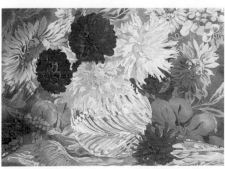

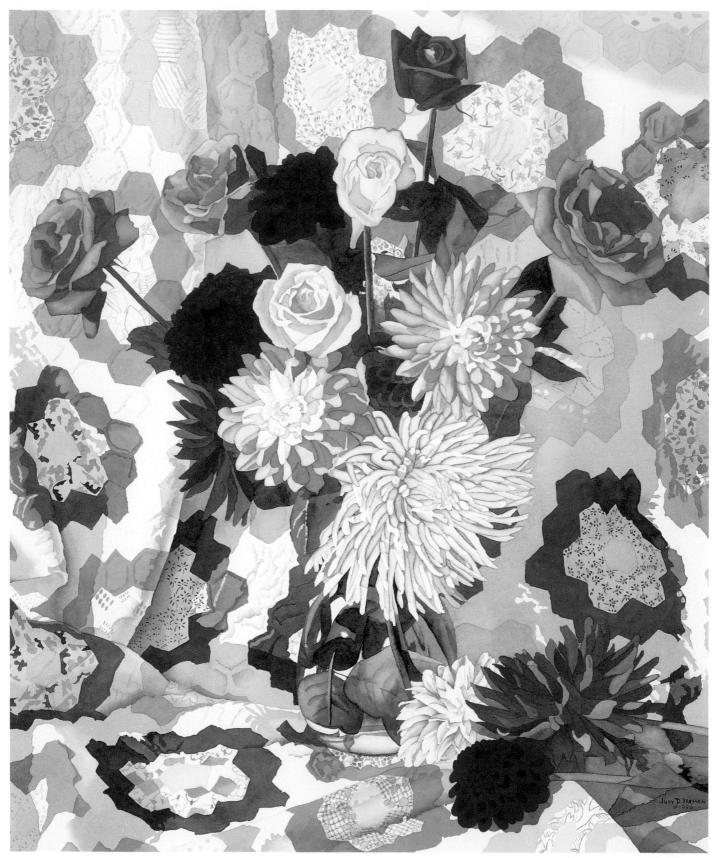

GRANDMOTHER'S FLOWER GARDEN
38″ × 32″ (96.5cm × 81.3cm)
Collection of the artist.

How Watercolor Captured My Heart

Many years ago I took an art workshop in which the teacher said, "You don't have to paint every hair on the horse." I said to myself, "But you can if you want!" I decided then and there to find my own way in the art world and to do it with watercolor.

What Makes Watercolor Brilliant and Beautiful

I believe there are three characteristics of watercolor that are key to creating "jewel-like" brilliant color: (1) the power of the white paper showing through transparent colors to give glowing colors; (2) the beauty of liquid washes of color; and (3) the ability to use water to push the pigment around to form crisp or soft edges. No other medium offers these three qualities, and they are critical to remember in your watercolor painting. Use them to your advantage at all times and in all ways to make beautiful watercolors.

Unique Painting Method

I have developed a unique method to paint watercolors that are highly refined rather than loose and sketchy. I do not proceed from light to dark, as in the usual method of watercolor painting. That is why I prefer beginning watercolor students not take their first class from me. I believe traditional methods are still the best way to learn. However, to painters with enough experience to pick and choose what benefits them, I can offer some different ideas and a new way of looking at watercolor.

I am not so self-satisfied that I hope to create Judy Treman clones. If sharing some of my techniques and discoveries helps other watercolorists make their paintings more powerful, then we are all better for it. Also, my methods seem to have merit whatever an artist's personal style: abstract or realistic, tight or loose.

Love Affair With Color

Bold color is a characteristic of my watercolors. My early paintings were small and earth-toned, but with the same strong compositions and values. As the years go by, my colors become bolder as the size and complexity of my paintings increase. My paintings are celebrations of life. While pushing myself to make ever larger and more colorful celebrations, I continually refine techniques for capturing radiant, jewel-like color—the shimmering, clear colors of the rainbow. I strive to create paintings that grab the viewer by the collar and demand attention.

Create Powerful Watercolors

Building a dynamic watercolor painting requires the masterful combination of an artist's technical skills, creative imagination and spiritual statement. While each artist's creative and spiritual statements are perhaps the most important part of his art, it is rare that an artist can achieve extraordinary art with inferior techniques. The artist's soul breathes life into his painting. We cannot teach what comes from the heart. However, with this in mind, we must continually fortify our technical skills to achieve the highest form of art.

Inspiration for this book comes from my five-day workshop for intermediate and advanced watercolorists, "Building Brilliant Watercolors," and the enthusiastic response of my students. A number of my methods are both innovative and useful, although in direct opposition to what my students have gleaned from earlier workshops. These differences in procedure include basic ways of handling paint, selection and layering of strong colors, and my "disappearing purple" technique.

This book focuses on the technical part of watercolor painting, with the greatest attention on the importance of color and values in creating brilliant watercolors. We will also consider purpose, subject matter, composition and techniques in applying paint.

Rome was not built in a day—and neither are my paintings! It takes me from four to six weeks to do a painting. My aim is to give you the tools you can use to build a strong and beautiful watercolor painting of your own, whether you choose to take an hour or a month to create it. In this book I hope to provide you with the foundation to build a brilliant watercolor using your own style and to inspire you to want to use the tools.

PAINT FROM YOUR HEART

Do not compare your paintings with mine or anyone else's. Each person has her own way of painting, and we all keep changing and learning techniques that enable us to paint from the heart. Art is creation from the artist's heart: That is what makes it so special.

Strategy for Brilliant Watercolors

BOUNTIFUL LIFE
39″×59″ (99.1cm×149.9cm)
Private collection.

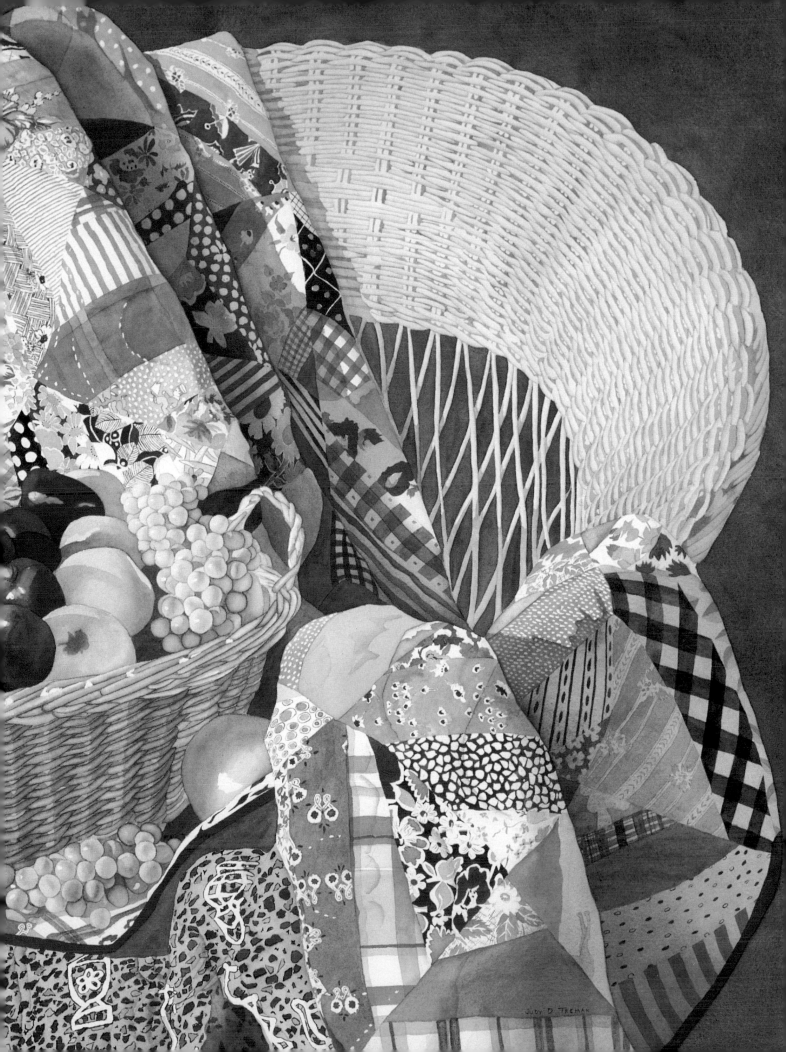

JUDY D. TREMAN

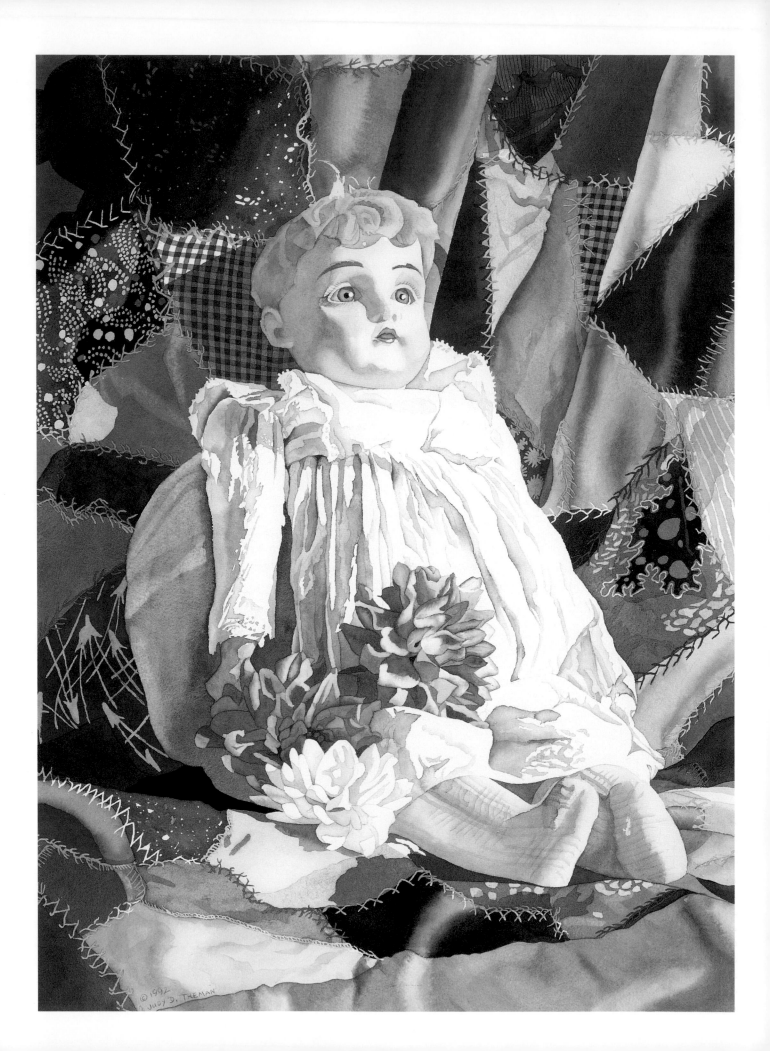

Make the Most of Your Paper and Paint

A feeling of power electrifies me when I behold what comes from paper and a few tubes of paint! The magic inspires me to make each painting a one-of-a-kind explosion of color and to paint the joy I feel. I know I reach some measure of success when I hear remarks like the one from the collector who said to me, "The tulips are like a chorus singing to me!"

Only watercolor gives such jewel-like brilliance. Each painting is a new adventure on a joyride of color soaring to new heights. The wonder is that we can take the viewer along with us on the ride. The special power of brilliant colors radiates joy and gives a spiritual lift.

This power is apparent in *Daydreamer*. Settling into a new home, I hung it on the wall of my small, sterile bedroom to enjoy before making it available for pur-

chase. Day after day my attention went to the painting, and each day I appreciated its beauty more. I no longer noticed the smallness of the room or its nondescript carpeting. I found myself not showing the painting to prospective collectors.

When I took *Daydreamer* to an exhibition, the life went out of the bedroom. It again became small, drab and cold. The dramatic change made me appreciate anew how a watercolor can be so powerful and beautiful that its presence can breathe energy into a spiritless environment.

In building brilliant watercolors, paper and paint become more than just materials. Utilizing the glowing, transparent qualities of liquid paints and white paper will help your paintings speak with purpose and radiance.

DAYDREAMER
29" × 21½" (73.7cm × 54.6cm)
Collection of the artist.

Paper and Paint's Brilliance

A German doll from the attic of my grandmother's house is spruced up for her portrait as the *Daydreamer*. The power of the white paper glimmers through the color and patterns of the quilt and gives a boost to the colors in the painting. Sunlight on the light hair and white dress of the doll makes her "pop" forward against the darker background shadows of the busy, multicolored quilt, giving depth and structure to the painting. Shadows give contours to the folds of the quilt as well as the doll. Reflected light shimmers with beautiful, rich yet delicate colors in the silk quilt, even in the darkest shadows. The interplay of sunlight and shadows makes an airy, dreamlike moment in time where your eye drifts from one area to another, as in a daydream.

White Paper Makes Your Colors Glow

The power of white paper showing through transparent colors is a key to creating brilliant watercolors. Light reflecting off white paper gives a *power boost* to watercolor pigments in a way no other media can. White paper reflecting light gives a translucent, jewel-like glow to your watercolors.

For several years I was lucky enough to live near a gallery that handled Dale Chihuly's vibrant glass art. I stopped in often to enjoy it. The gallery owner remarked one day that, after seeing my paintings, he could understand why I enjoyed the colorful glass so much. The glass art's brilliant, translucent colors were like those in my paintings.

I remember as a child being fascinated by stained glass windows and their rich glowing colors. The colors are beautiful on a gray day, but sunlight makes the windows come alive as it shines through the deep colors. In each painting I try to capture this power of sunlight shining through brilliant colors. White paper is sunlight to the watercolorist!

You can give your paintings brilliance by making sure the white paper shines through even the darkest shadow areas. By contrast, in photographs the shadow areas often appear almost black, with no definition. When you paint from photographs, you must be aware of these dark areas so your shadows do not become "black

Use White Paper as Sun

Sun shining through stained glass windows gives colors a dramatic radiance. The blue of the woman's dress shimmers with an inner glow. Blue grapes and green leaves sparkle like jewels in the sunlight. The colors take on a magical intensity that is hard to capture with a camera.

Think of your watercolor painting as a stained glass window and the white paper as the sun. Use colors transparent enough to see through to the white paper, and you are on your way to brilliant, jewel-like color.

holes" without meaning. Sometimes the most beautiful colors are in the shadows. You can use white paper shining through transparent colors to keep color alive in shadows, or you can use white paper alone to emphasize sunlight.

Types of Watercolor Paper

Watercolor paper comes in a variety of surface textures, from rough, which has a heavy texture, to hot-pressed, which has a smooth, glazed surface from pressing the paper through hot rollers. Cold-pressed, somewhere in between rough and hot-pressed, has a degree of surface texturing.

My preference is rough paper, which surprises many people, because my paintings are so detailed. However, I like the painterly quality of rough paper, so I paint on it exclusively. I recommend either rough or cold-pressed acid-free paper, but not hot-pressed paper. In my experience, hot-pressed paper is not receptive to the glazing techniques I use.

Weight of watercolor paper (the weight of one ream—500 sheets—of a specific sheet size) varies from 90 lb. to 300 lb. (190g/m^2 to 640g/m^2). Heavier paper, which I prefer, has less tendency to buckle, a quality that is important when working on sheets $30'' \times 40''$ (76.2cm \times 101.6cm) or larger. This ability to handle more paint without buckling is crucial when you build up your painting with layers of glazes, or when you slosh around copious washes. The pigment will settle into the low places in buckled paper, resulting in an uneven wash.

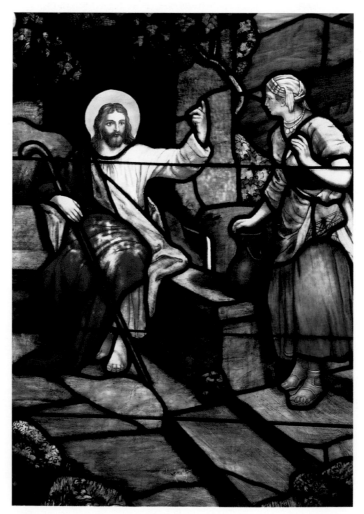

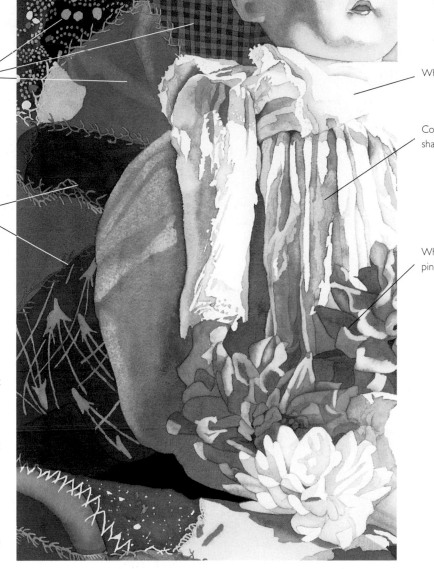

Patterns and textures glow through shadows.

White paper defines sunlight.

Colors glow even in the darkest shadows.

Even tiny details show through shadows.

White paper gives a boost to the pink dahlias.

White Paper Shines Through Color

There is no black-hole shadow area in *Daydreamer* (page 12). Even in the darkest shadows, the white paper glimmers through the color and patterns of the quilt and gives a power boost to colors in the painting. Each color glows as the power of the white paper shines through the transparent colors. Though the colors are delicate, they are at the same time very rich.

PROTECT YOUR PAPER

Do not touch your watercolor paper with your hands—even when making your drawing. Oils from the skin alter the absorbency of the paper and create uneven and unpredictable results. I rest my brush hand on a small piece of heavy rag paper and move it around while I draw and paint.

Good-Bye Old Paint

While teaching my first advanced watercolor workshop, my students were dumbfounded when I asked them to discard their old, dried paint and to squeeze out fresh color onto clean palettes. They were quick and confident in pointing out to me that they had been taught to squeeze the paint into the palette wells, let it dry, and then paint from the dried wells by putting a little water on the brush and scrubbing around, moving it to the center of the palette and mixing some more.

Several students had been told to squeeze the entire tube of paint into the well, let it dry and then paint. Ever mindful of wasting expensive paint, they used the dried paint until it was gone. My class insisted that their dried, caked paint palettes were the norm. Now I was suggesting that their dried paint was "dead"—and they should bury it!

Taking a painful leap of faith, my class did what I asked. During the course of the workshop they became converts to painting with "live" color. They loved the brilliant colors and ease of painting and mixing. They marveled at the difference and said they would never again paint with dead paint.

Fresh Tube Watercolors vs. Dried Watercolors

When I began to paint my large, brilliantly colored watercolors, I needed large amounts of transparent paint to load on my brush and fill the paper. Mixing quantities of paint from dried pan watercolor paints, however, was almost impossible. I turned to tube watercolors. Not only was I able to quickly mix copious washes, but the luscious colors enchanted me.

Experimentation also convinced me that, once dried, tube paints do not mix as well as when kept in their more liquid form. When reconstituted, dried sedimentary granules of pigment are suspended in water, giving grainy, dull, unpleasant washes and mixes. The reconstituted paint is not as transparent, brilliantly colored or smooth as liquid tube paint that has never been allowed to dry!

Each brand of paint offers a slightly different formulation. The manufacturer bases opacity and transparency ratings on the scientific formulation of the paint. I use Winsor & Newton for all the paintings and exercises in this book, except the art on page 58, which is done with Holbein colors. In looking at color theory and color wheels in technical books, watercolorists differ greatly in their descriptions of each color's opacity and transparency. When artists talk about the transparency of a particular color, they first need to establish what *brand* of paint it is, and whether it is *reconstituted* or *liquid*.

Technical Verification

A technical expert at a paint manufacturer verified by phone what my own experience had taught me. He said dried pan paints are meant to be reconstituted with water; liquid tube paints are a different formulation and are *not* meant to be reconstituted after they dry. He commented that reconstituting dried tube paints breaks the formulation of the paint and reduces the quality of paint, so that it lacks luminosity. He used the term "degradated" to refer to reconstituted paint, a deteriorated condition of the paint.

I also learned that his paint company has published articles recommending that artists not reconstitute dried tube paints, and that artists generally ignore the advice, thinking the company is trying to sell more paint! If use of reconstituted paint is as widespread as my students suggested, I wonder how dramatic the changes would be if all watercolorists used *live* paint.

AMISH SUNSHINE AND SHADOWS
38½" × 27½" (97.8cm × 69.9cm)
Private collection.

Liquid Pigment Gives Rich Color
Clear, bright colors result when you use juicy, never-dried tube paints. In the *Amish Sunshine and Shadows* quilt pattern, each color modulates into three consecutively darker shades of the same color, pink to red to burgundy. It is the same with pale lavender to violet to purple, and also with the greens and blues. I purposely selected dahlias of pale pink, medium pink and dark pink (burgundy) to echo this idea of sunshine and shadows. You could not get these rich colors with reconstituted dried paint.

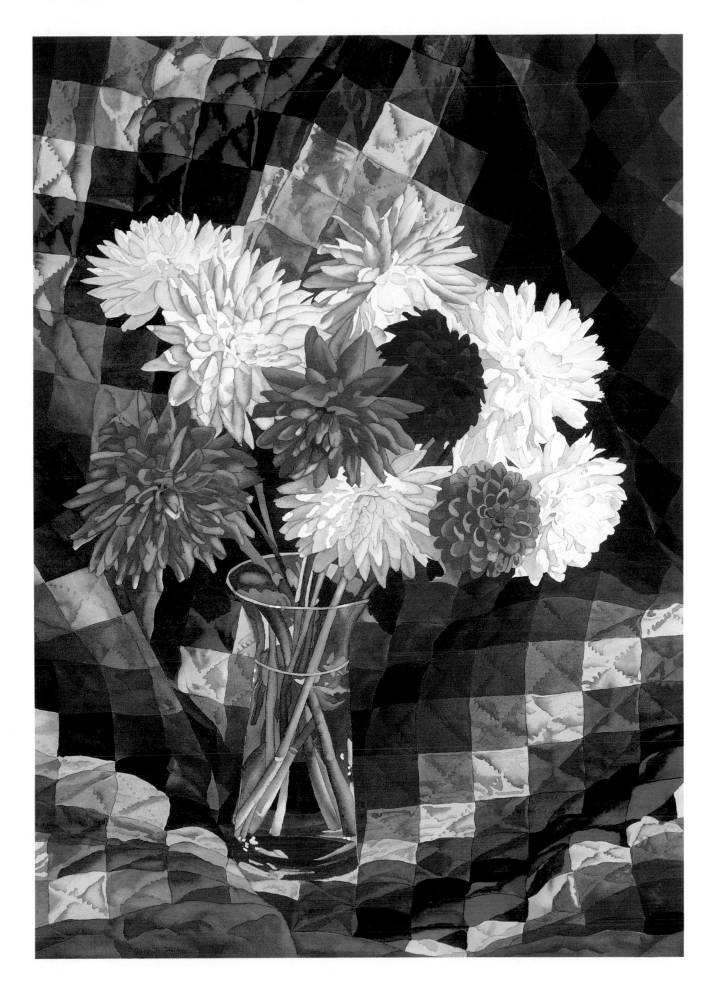

Never Let It Dry

Professional-quality watercolors in tubes offer juicy and brilliant colors with marvelous mixing capabilities *if kept liquid* and never allowed to dry. I keep them in liquid form by adding water as needed to counteract evaporation, never allowing them to dry in the palette.

Several times during the day, as the water evaporates, I spray my palette with water to keep the colors liquefied. When I quit for the day, I spray the palette again and put on the lid. I usually put my palette in the refrigerator overnight to preserve the paint as long as possible.

Liquid watercolors preserved this way last about three weeks, after which they develop mold. Mold shows as dark spots on the surface of the paint, most often in yellows and reds. At this point I dump all the leftover paint and start over with a clean palette and fresh tube watercolors, squeezing out the amount I expect to use in two or three weeks.

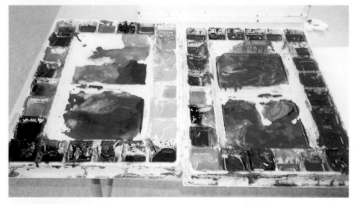

Dead Paint!

Wet or dry, the paints on this palette are a muddy mess! It is impossible to paint clear, brilliant colors using them, yet many watercolorists try. The colors have lost the purity of their tint and will run together when you add water. When reconstituted, they will appear dull, grainy and lifeless.

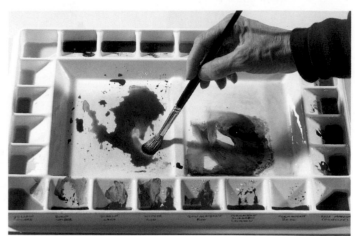

Palette Ready for Painting

Use live, never-dried tube paints as your first step in mastering brilliant watercolor. Try to keep each color separated to preserve the purity of the tint. With this palette, clean and brimming with luscious, juicy colors, you can paint jewel-like hues. The purple will keep its transparent brilliance. You can manage each color on its own and choose which ones to mix together. You will spend your time painting—instead of ruining your brush scrubbing to reconstitute paint. The liquefied paint is ready for beautiful washes and mixes.

Add Water for Easy Flow and Vibrant Color

I like to use unmixed, straight-from-the-tube colors directly from the paint well, but tube watercolor paints are too thick to apply to the paper in a transparent wash without adding water. I spray distilled water in an amount equal to the freshly squeezed liquid pigment in each well of my palette thirty minutes to an hour before I begin painting. This allows time for the water to mix with the tube color in the well. The tube color seems to absorb the water uniformly on its own. The result is paint with a juicy consistency, ready for the artist to dip the brush into each well and apply the paint directly to the paper, or to mix it on the palette.

Diluting tube watercolors also enhances the power of the white paper to shine through the pigments. This liquefied paint gives transparency, brilliance and pristine freshness to watercolor painting.

Students in my workshops react with wonder when I ask them to spray water into each palette well that is equal to the amount of paint in that well. The reason becomes apparent to them when they try to wash color on large pieces of paper.

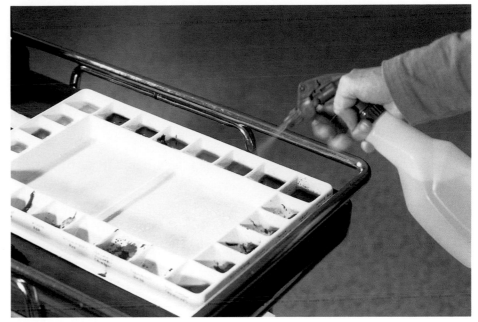

Add Water to Paint
Spray an amount of water equal to the amount of liquid tube watercolor pigments into each palette well. Leave it about thirty minutes. The paint will automatically absorb the water and will be of the perfect consistency to start painting, without all that messy scrubbing and softening.

TIPS FOR HANDLING LIQUID TUBE WATERCOLOR PIGMENTS

Keep Tubes Clean
As you put paint into your palette, use a folded, damp paper towel to wipe stray paint from the top of each tube. This prevents caked paint and hard-to-open tubes.

Label Paint Wells
Especially if you use many colors, as I do, it is helpful to write the name of the color with a permanent marker outside each palette well. When you put the same color in the same place every time, you quickly develop a feeling for where each color is, making it easy to always reach for the right color.

Refrigerate Leftover Paint
Refrigerate your paint-filled palette overnight. The liquefied paint will last longer with less evaporation and less tendency to produce mold. Just slide on the lid and put the whole tray in the refrigerator. The paint will be ready to use again in the morning.

1. White paper is like sunlight to the watercolorist.

2. Transparent colors allow the white paper to shine through even the darkest areas.

3. Give your painting a power boost by making sure you can see white paper showing through all your colors.

4. Use only live, never-dried paints, and keep them liquid to maximize brilliance and transparency.

5. Get rid of reconstituted dried paint.

6. Mix paint in the palette wells with equal amounts of water.

7. Protect your paper from the oils on your hand.

USE HIGH-QUALITY MATERIALS

Use the best paper, brushes and paint you can afford, even for practice. Do not waste your creative talents on inferior materials! You cannot paint brilliant watercolors with anything less than the best. If you practice with inferior paper, paint or brushes, you will never reach your potential. Experiment on the paper you use for your paintings so you will know how the paint works.

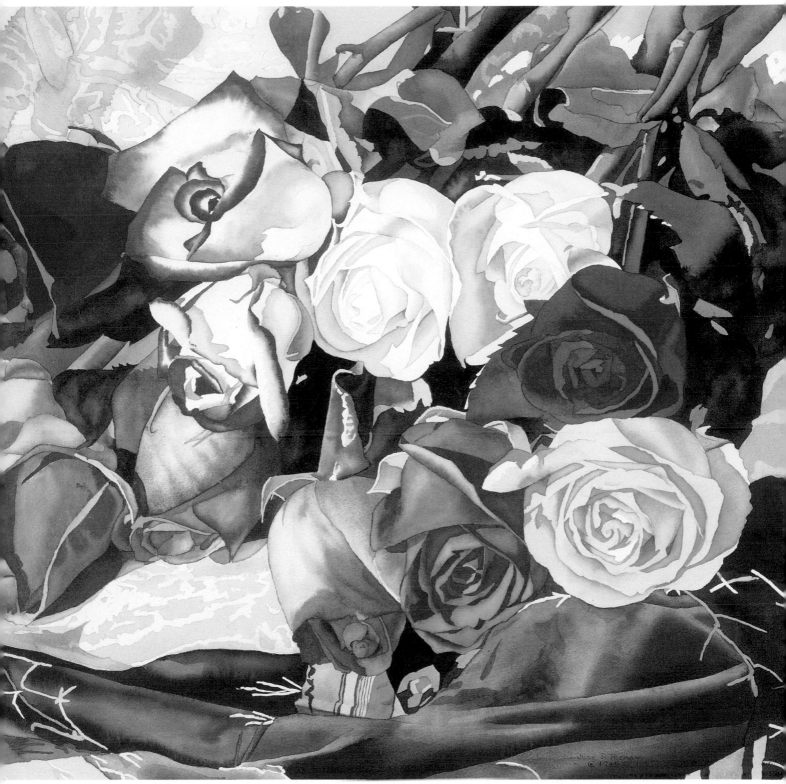

Live Paint, Brilliant Color

Kudos is a bouquet of fresh-picked roses hand-delivered by the artist to the viewer. With its myriad colors and each tight rosebud up to 8″ (20.3cm) in diameter, *Kudos* requires all the clear, brilliant colors I can create. Each petal has to be achieved in one wash or it loses its translucent freshness. Only *live* liquid paint can capture all the subtleties of the delicate color nuances, clear glazes and blazing opulence.

KUDOS
27½″ × 39½″ (69.9cm × 100.3cm)
Private collection.

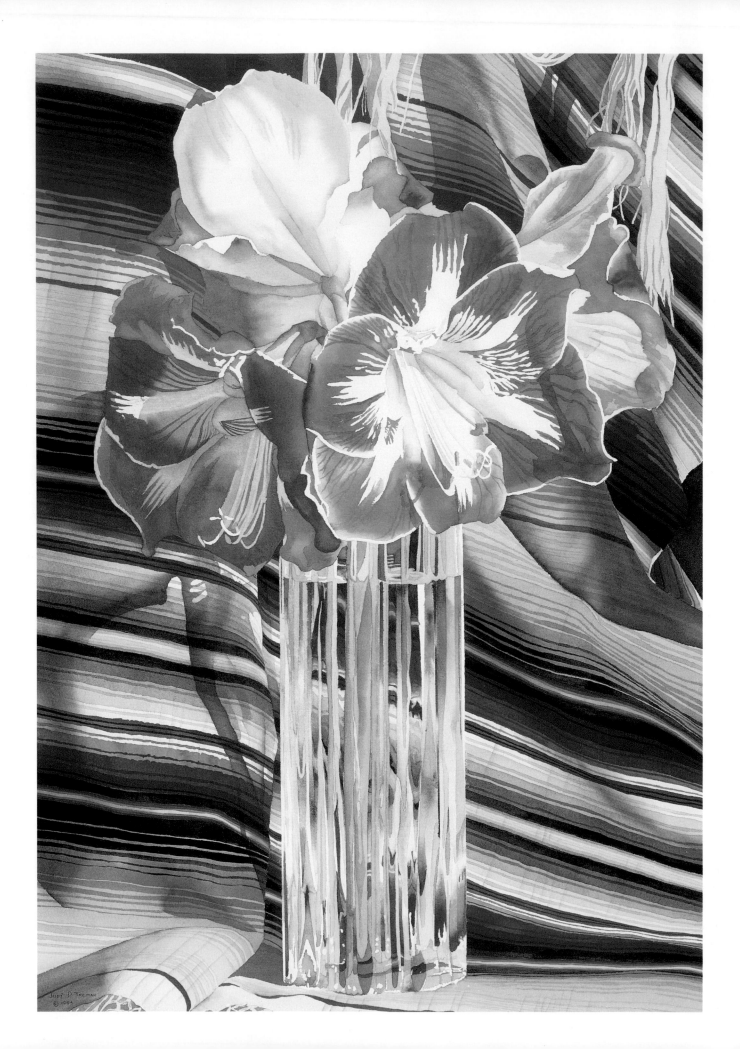

Plan Before You Paint

Sometimes the color, drama, excitement or beauty of subject matter strikes us so powerfully we jump right into a painting. When we get into the middle of the painting, we may suddenly realize it is not working. Something is not right, or is out of balance, in the painting, distracting us so we cannot fully enjoy the artwork. To work as a painting, it must have a purposeful handling of subject matter, well-designed composition, competent application of paint and effective use of value and color. These elements work together harmoniously. A poorly conceived component strikes a jarring note with the viewer—and spoils the effect.

It is often difficult for my students to focus on the subject they are painting. They look at a scene and want to paint everything they see. They are surprised when I suggest they paint only the single part of the scene that is most important to them. They can later make separate paintings for each of the other components.

To paint with brilliant colors in large, complex compositions, you need to think about your painting before you start. In *Fanfare* (opposite), the basic elements of design—inspiration, purpose, subject, composition, value, color, size and details—are all carefully planned to achieve a dynamic painting that blares out its message of joy.

Without planning, we might be well into a painting before noticing a problem with the composition. In a painting like *Fanfare*, it would be too late to move the flower or add another. If the value statement is not strong enough, it is too late to do anything except begin again. Make sure you have a fully developed plan *before* you start painting.

FANFARE
39½″ × 28″ (100.3cm × 71.1cm)
Collection of the artist.

Design Dynamic Paintings
From its trumpet-shaped amaryllis and brilliant color to its beautifully arranged shadow patterns, this painting radiates excitement. Colorful stripes intriguingly interweave throughout the amaryllis blossom, the serape and the vase, making a very dynamic painting. Your eye moves easily from one element to the next. Attention returns to the amaryllis blossoms, proclaiming their message of joy!

Clarify Purpose

Start with the questions, "What am I painting and why? Do I want to capture a moment or portray a special subject? Do I have a message or a feeling I want to express? Do I want to show something beautiful, or portray intriguing shapes and colors?"

Think about the idea and inspiration for the painting. What is the main idea you want to emphasize? What do you want to say? If you do not know, the viewer will not be able to determine it.

In *Fanfare* (page 22), the idea is the bold, trumpetlike amaryllis blaring out a message of joy. All parts of the painting lead you back to the amaryllis. All the stripes and colors radiate the joyful theme.

Do everything in your power to make sure the viewer gets the idea of the painting. Select subject matter, size of the painting, colors, values and amount of detail to make your point. You do not have to paint every stitch in the quilt—but you can if you want. Just make sure it works as a painting first and that the viewer receives the message. Details are distracting if they destroy the overall impact of the painting.

Usually the title comes to me at the earliest stage of painting. I have a feeling or quality that I want to capture, which is why I wanted to create the painting in the first place, and the title describes this quality. *Fanfare* is a showy display, or a lively sounding of trumpets. Everything about the painting describes these qualities.

In *Bountiful Life* (pages 10-11), I wanted to show the overflowing abundance of the harvest and the beauty in the world around us. To portray this, I started with size. The painting is a colossal 39″ × 59″ (99.1cm × 149.9cm). I used a basket overflowing with fruit; the apple peel comes right out of the front of the painting. Most people who see this painting cannot resist the urge to touch the apple peel, because it truly looks as if it comes out of the picture plane. I included a couple of colorful patchwork quilts; all the elements work together to show life's bounty.

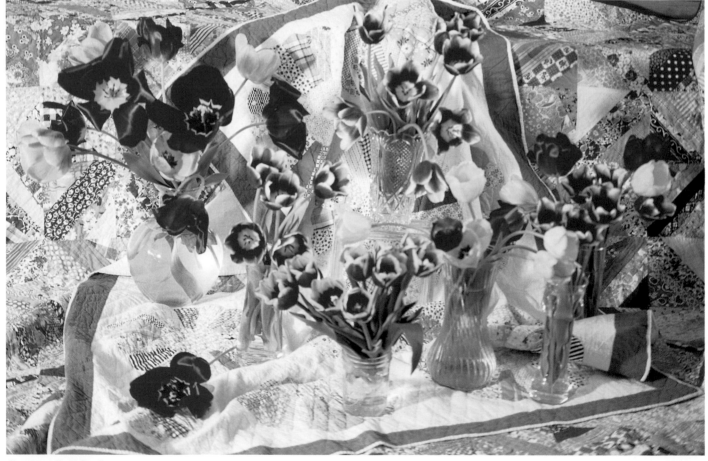

Sensory Overload

This still-life setup causes a sensory overload! The viewer might wonder what the subject is. Do not try to paint it all at once, and do not be afraid to make changes to colors and subject to enhance the painting. Focus on your purpose and select your subject. You must know what your subject is if you want your viewer to understand the point of your painting.

Determine Subject Matter

Figure out what your subject matter is. This may sound obvious, but it pays to think about it! Why is this the best subject matter for this particular painting? Am I ready to paint this subject, or do I need to practice? How much of the subject matter shows? What will the background be, and why?

Emphasize the essence of what your painting portrays—make sure the subject is readily apparent. Exaggerate to make a strong point. Make the lights lighter and the darks darker. If it is a pale pink rose, make it paler than real life. Make it realer than real. People looking at my paintings often remark on the beauty of the background quilts or blankets, and express disappointment when I show them the actual quilt or blanket. They say the real thing is not as spectacular as my painting. In *Fanfare*, although the painting is 39½" × 28" (100.3cm × 71.1cm), the actual serape is only about 15" × 20" (38.1cm × 50.8cm)—much smaller than the painting. I exaggerate its size and colors for a stronger impact.

Meaningful Subjects

Paint what you love! The subjects of most of my paintings are meaningful to me—a quilt made by, or corn or flowers grown by, someone special. When you put what is close to your heart into your painting, the painting rings true to the viewer. The viewer will understand the point of the painting, your purpose in creating it.

Draw a Thumbnail Sketch

Draw thumbnail sketches to try out different ideas, subject matter, compositions and designs before you paint. Select the sketch you like best for your painting. Use a plastic slide mount (shown above, right) to aid in placing elements of your drawing. Match up diagonal lines of your thumbnail sketch with your final drawing.

Look for pleasing design and bold impact. Think about your purpose and how best to achieve it. Check for compositional pitfalls. It is easier to correct problems at this stage than after you draw and paint on your watercolor paper. Try to solve painting problems at the thumbnail-sketch stage.

A Simple Tool Can Help Your Painting

Use this simple tool to help you zero in on your subject: Look at your subject at a distance through an empty slide mount. Move the slide mount around to frame different composition possibilities so you can choose the most pleasing composition to effectively accomplish your purpose.

The slide mount also helps you with your drawing. Securely tape a string across each diagonal on an empty plastic slide mount. I use heavy embroidery thread and drafting tape. Be sure to line up the string with the exact corners of the slide mount. If your paper shape is different, tape along one side of the slide mount, keeping the mount shape proportional to your paper shape.

Lightly draw lines along the diagonals on your paper. Now look at your subject through the diagonal strings on your slide mount, and begin your drawing. Use the diagonals of the slide mount and the corresponding diagonals on your paper to keep your drawing correct in proportion, size and placement. This tool also provides an easy way to check on common compositional errors and to see if the drawing is out of balance. It makes thumbnail sketches a snap!

CHOOSE A CENTRAL SUBJECT

Two subjects of equal importance fight with each other. It is usually better to choose a central subject and a subordinate subject.

Create Compositions That Work

Too many bright, bold colors and details can overwhelm the composition in a work of art, especially as the size of the painting increases. If you plan your composition carefully before you begin to paint, you can use color and detail without letting the painting become overworked or cluttered.

Composition gives form to your painting, just as a skeleton gives shape to your body. Try for a strong design, such as the bold design of *Fanfare* (here and page 22), which positively catches your eye.

Make Your Subject Stand Out

Be sure the viewer sees and understands your subject by making it stand out against the background. Make the subject a different value and/or color from the background, unless your purpose is camouflage art. In *Fanfare*, the edges of the vase and blossom sharply stand out from the stripes in the serape.

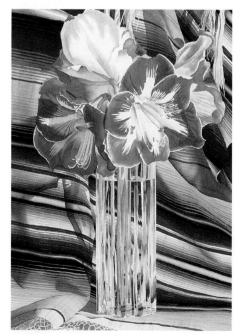

FANFARE
39½″ × 28″ (100.3cm × 71.1cm)
Collection of the artist.

Design a Balanced Composition

If your main subject is in one corner, the painting may look too heavy on one side, or lopsided, and the viewer might not even recognize it as the subject. In *Fanfare*, the vase is in the center because the subject's complexity in color, stripes and details requires an anchor, or sense of stability. It gives balance to what might otherwise be a whirligig of activity.

On the other hand, be careful not to split the painting in half vertically, diagonally or horizontally by the use of color, value (light and dark), line or shape. A one-third to two-thirds division is more pleasing to the eye.

Keep the Viewer's Attention With Dynamic Composition

In *Fanfare*, the folds in the serape, the shadows, and the colors and values all interweave to keep the viewer's eye actively moving within the painting. Be careful not to lose your viewer by letting his eye wander out of the painting or become confused. Do not trail off in exactly the corner. Avoid parallel lines going across the whole paper or along an edge. *Fanfare* is very lively. Observe the way your eye moves around the painting. Every time your eye heads toward a corner, an element brings it back into the composition.

Try for a dynamic, active composition. Keep the eye moving by using shapes that lead from one to another, or by repeating colors in different areas.

Repeat beautiful shapes and colors in subject matter, light and shadows. For example, select a vase that repeats the shape of the flowers and the background. In *Fanfare*, stripes repeat throughout the serape, vase and amaryllis. Red, particularly, repeats throughout the composition, tying the parts together.

Keep the Big Picture in Mind

Avoid being so enamored of details that you lose the big picture, or basic design. Squint your eyes to see big shapes, or turn your painting upside down to see if it still looks balanced.

Another way to check the basic design of your painting is to look at it in a mirror. Seeing your painting in reverse will often show mistakes in composition, drawing or perspective (such as something that is out of balance), as well as underdeveloped or overworked areas. As you work on a painting, you become used to it and cannot always judge it with a critical eye. Looking at your painting in a mirror gives you a fresh viewpoint.

Fanfare is so awash with color and stripes that it could have been chaos; bold, dark shadow shapes make this painting work. The basic design is so strong that the details do not confuse the viewer.

In the end, remember that rules are made to be broken! Let your eye and instincts work for you to say what you want to say.

Common Compositional Problems

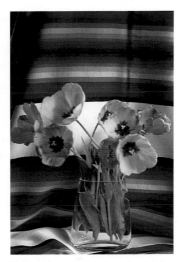

This arrangement of tulips is pleasing, but the composition is out of balance, with the subject and the background stripes weighing heavily to the right side. Your eye follows the stripes above the tulips right out of the painting. The artist has lost the viewer. Also, the stripes are parallel with the right edge. This leaves an unconnected white area to the right of the tulips.

Furthermore, it is difficult to see the middle tulips because they blend in color and value with the yellow in the stripe. If you squint your eyes, you have difficulty seeing them. The orange stripe continues the full length of the still-life setup, so the vase shape is lost in the serape.

The diagonal stripe divides this still life in half and leads your eye straight out the corners of the picture plane. Say *adios* to the viewer. The tulips do not stand out against the same color and value in the stripes. The upper left triangle does not connect to the rest of the painting. Straight parallel stripes lack excitement. The vase shape blends into the same color in the background. If you squint your eyes, you cannot see the vase at all.

A straight horizontal stripe divides this still life in half and leaves a blank white area above the stripe, which is not connected to the rest of the composition. Tulip edges blend with the same color in the stripes; the vase blends into the same color in the serape. The viewer's eye follows the stripes out of the picture at either side.

Tulips show up against the background stripes of a different color. However, the eye follows the straight stripe out of the picture plane on either side, and the viewer's attention is lost. Straight stripes give a static, immobile feeling. The top section of stripes is particularly stagnant and unconnected. Notice how details of the still life are lost in the black hole of the shadow at upper left; cameras are not able to successfully reproduce shadow details.

1. Think about and plan your painting *before* you paint.

2. Choose your main subject matter; don't try to paint everything you see.

3. Make your subject stand out against its background.

4. Keep your painting balanced.

5. Avoid dividing the composition in half.

6. Keep the viewer's attention actively moving within the painting.

7. Look for, emphasize and repeat beautiful shapes and colors.

8. Make sure your basic design shows through all the details.

ELEMENTS OF DESIGN

Without purpose, subject, composition and values, we waste brilliant colors and details.

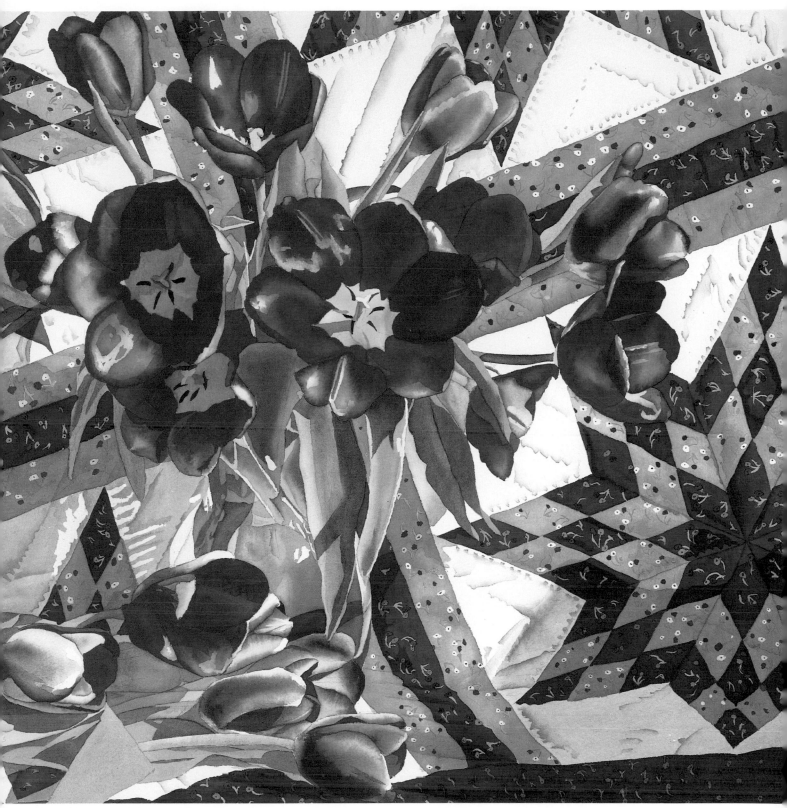

A Well-Designed Composition

The sprightly tulips grab your attention first and stand out clearly against the rich colors of the background quilt. The painting is well balanced. The swirling colors of the quilt keep your attention moving back into the center of the painting and work with the diagonal pattern to create an exciting, dynamic quality. Shapes and colors repeat from foreground to background and make a pleasing pattern.

GAIETY
27½″ × 39″ (69.9cm × 99.1cm)
Private collection.

The Power of Color

CELEBRATION
39″ × 59″ (99.1cm × 149.9cm)
Private collection.

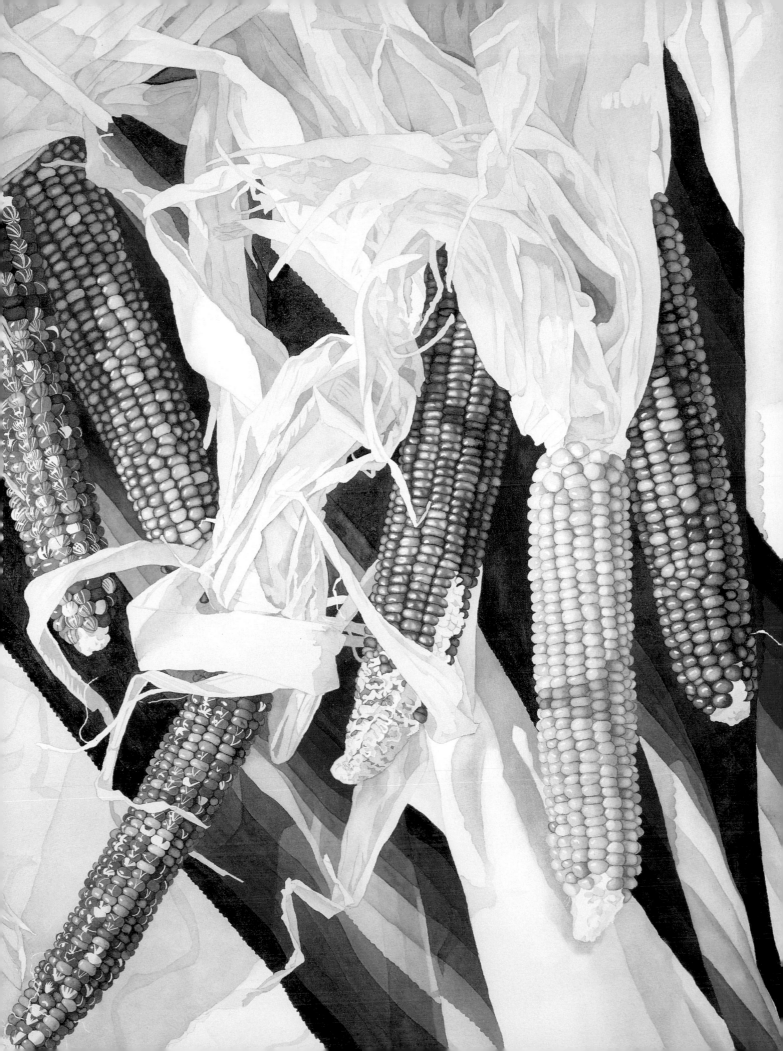

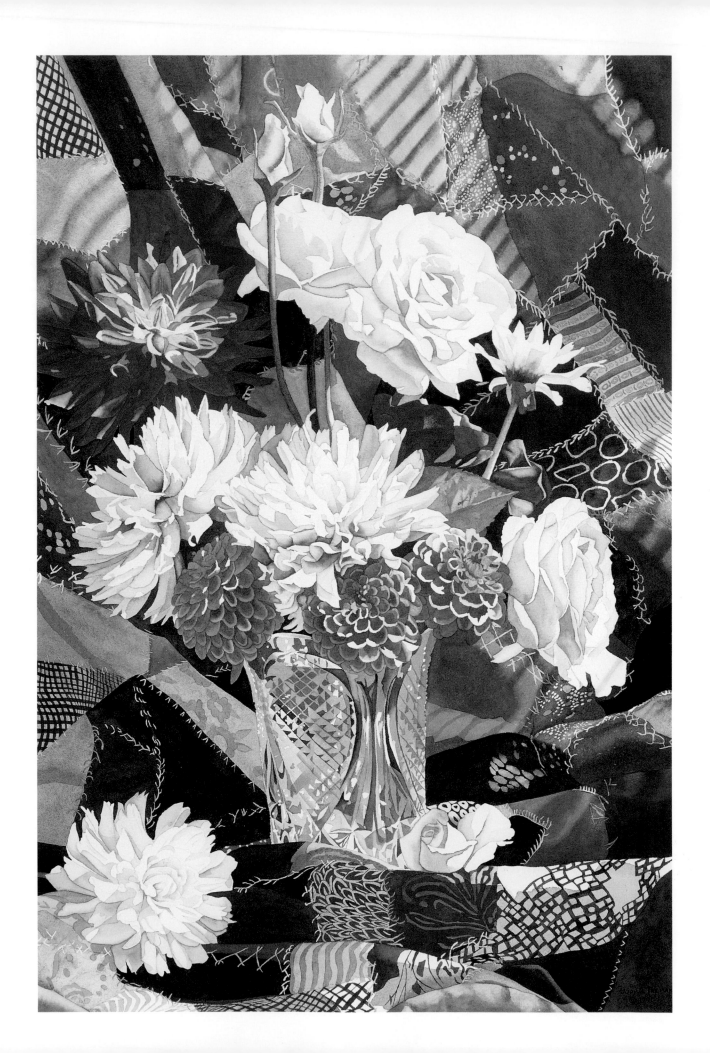

Know Your Colors' Characteristics

Color works in my paintings! When my twelve-year-old nephew looked at one of my paintings, he remarked, "That painting makes me smile on the inside." All the colors in the painting help evoke the joyous feeling I want to portray. Joy is a reaction people often have to my paintings, and it is my purpose in painting. Color is the way I express joy.

My watercolor *Joyful Faces* (opposite) was hanging at a Frye Art Museum exhibition in Seattle. A man stood looking at it, hands on hips, unaware that the artist was standing right behind him. "Way too much color!" he exclaimed. I wanted to go up, shake his hand and say, "Thank you, that is just what I was trying to do."

I love color—the more the better. However, there is more to it than loading your palette with brilliant colors. Too many colors can easily destroy the composition and design of your painting.

We describe colors by hue, saturation and value. The most basic way is by *hue*, or name, as in red, blue or yellow. *Saturation* is a color's intensity or vividness (adding water to a color decreases its saturation). *Value* is the range from light to dark, most easily understood as the grays between white and black. Thus, we can describe the color of the pale pink roses in *Joyful Faces* as pink in hue, of low saturation and light in value.

An astonishing variety of colors opens up to you as you immerse yourself in watercolor. It's critical to understand the characteristics of colors so you can choose, and use, them effectively, which gives you more power to express yourself and to achieve desired effects. If you're in control technically, your creativity is free to express itself. You can choose between transparent or opaque colors, staining or nonstaining colors, and powerful or weak colors. There are textural choices as well, from granulated color to clear, smooth color. The color chart on pages 38-39 will help you understand the characteristics of each color in relation to other colors, no matter which brand of paint you use.

JOYFUL FACES
28½″ × 39″ (72.4cm × 99.1cm)
Private collection.

Kaleidoscope of Colors

Understanding the characteristics of colors makes it possible to use a kaleidoscope of hues that works together to form a lively, yet cohesive, painting. Just look at all the different colors in the quilt! Yet they do not overpower the main subject—the flowers. Choosing colors from the cool side of the color wheel makes sure the colors relate well to each other. Warm reds or yellows would be too jarring in contrast to the cool colors in the painting. Transparent colors allow the white paper to glow through, giving jewel-like colors. Granulated colors add texture and interest. Staining colors give a rich vibrancy.

Arrangement of Colors

The Color Spectrum

Nature helps us understand the relation-
ship between colors when we look at a
rainbow or the colors cast by a ray of light
through a prism. Bands of intense color
gradually modulate from red to orange to
yellow to green to blue to violet as each
color takes on pigment from the adjoining
color.

The Color Wheel

A color wheel, which represents the ad-
joining colors that occur naturally in the
spectrum, helps you understand the rela-
tionships between colors. To make a color
wheel, simply join two ends of the color
spectrum together, violet to red. Colors are
arranged around the wheel from red to or-
ange to yellow to green to blue to violet.

Light Ray

Prism

Red

Orange

Yellow

Green

Blue

Violet

Color Spectrum

Light Ray Through a Prism

A light ray cast through a prism separates into a full spectrum of intense brilliant colors, from
red to orange to yellow to green to blue to violet. Within each primary color (red, yellow and
blue), colors take on the characteristics of their neighbor as they gradually modulate through the
secondary colors (orange, green and violet).

Arrange Colors on Your Palette

It is helpful to arrange the colors on your palette in a way that is useful to you, like a color wheel, rather than haphazardly. Think of the relationships between colors, and notice which colors are warmer (containing more orange) and which colors are cooler (containing more blue). When you start mixing colors, this knowledge will pay big dividends in luminous colors. When arranging colors on your palette, you will need to be familiar with the colors' temperatures (see page 40). Squeeze colors into the deep palette wells, starting with cool yellows and warm yellows, and advancing to warm reds, cool reds, violet, blues, yellowish blue and greens.

If you place the colors in the same palette well each time, you will automatically reach for the color you want. Color selection becomes instinctive as you learn how the colors work. Because colors adjoining each other on the color wheel make the most brilliant mixes, when you arrange colors around your palette according to the color wheel, you can easily select the most brilliant adjoining colors.

Keep Colors Separated
My palette has large, deep wells to hold pigment. An equal amount of water is mixed with the pigment to make it more fluid. I am a stickler for keeping the colors separated and pure within each well. My palette looks like this every day before I begin painting. I only dip my brush into the pigment well if it is clean or has the same color. This requires a lot of brush washing, but results in pure, clear colors. I do not leave dried paint on the palette!

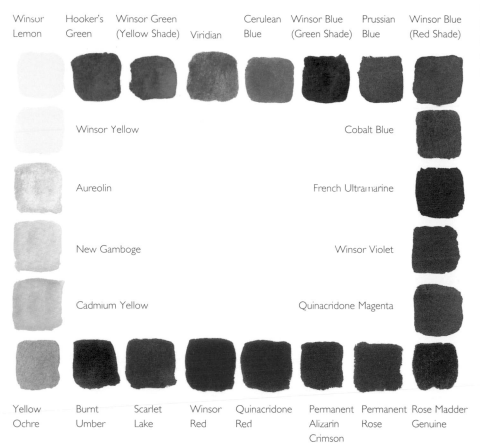

Winsor Lemon Hooker's Green Winsor Green (Yellow Shade) Viridian Cerulean Blue Winsor Blue (Green Shade) Prussian Blue Winsor Blue (Red Shade)

Winsor Yellow Cobalt Blue

Aureolin French Ultramarine

New Gamboge Winsor Violet

Cadmium Yellow Quinacridone Magenta

Yellow Ochre Burnt Umber Scarlet Lake Winsor Red Quinacridone Red Permanent Alizarin Crimson Permanent Rose Rose Madder Genuine

Arrangement of My Palette
My palette has twenty-four wells for color. Going counterclockwise from the upper left corner are cool yellows, middle yellows, warm yellows, browns, warm red through cool red, violet, reddish blue, yellowish blue, and cool green to warm green. The circle keeps going to the beginning. Arranging warm colors adjacent to warm, and cool colors next to cool, makes it easy to select colors that mix well together. Furthermore, if you always place a color in its specific well, you will automatically know where your colors are each time you paint.

Primary, Secondary and Complementary Colors

The color wheel groups the *primary colors*, yellow, red and blue, in a triad. Primary colors are pure colors, not mixes of other colors. Theoretically, you can create all other colors with different combinations of the primaries. Primaries are the purest, most brilliant pigments, and transparent primary colors best allow the white paper to show through the pigment. They should be your first choice if you want brilliant color.

Secondary colors are mixtures of two primaries: orange from yellow and red, violet from red and blue, and green from blue and yellow. Secondary colors are placed midway between primaries on the color wheel. Being a mix of two colors, secondary colors are brilliant, as seen in the spectrum, yet slightly less so than primaries.

Complementary colors are on opposite sides of the color wheel. Red's complement is green, yellow's complement is violet, and blue's complement is orange.

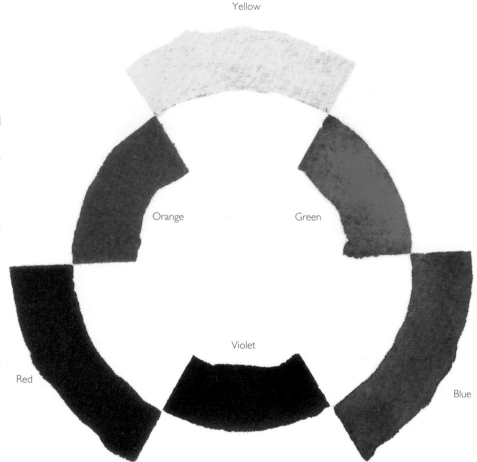

A Simple Color Wheel

You can organize a color wheel around primary, secondary and complementary colors to show you how the colors relate to each other. Primary colors (yellow, red and blue) form the outer circle of this simple color wheel. Secondary colors (orange, violet and green) form the inner circle and are mixes of adjoining primaries. These are the colors of the spectrum and rainbow. Complementary colors (yellow/violet, orange/blue and red/green) are opposite each other on the wheel.

Make a Color Chart to Categorize and Compare

Make a simple color chart to help you understand the characteristics of each individual color on your palette. A chart helps you see and relate warm and cool colors. It helps you identify transparent and opaque colors by seeing how well each color shows up over a dark color or black. You can see what each color is like in its saturated, full-strength power, and how it appears diluted. It helps you see how each color glazes over each other color. As you add new colors to your palette, make a new chart to see where the new colors fit in and how they act.

This color chart will be your guide throughout your watercolor explorations. Refer to the chart until your feeling for each color is so automatic you no longer it.

MATERIALS LIST

Paints: All the colors on your palette
Brush: no. 7 sable round
Paper: 140- or 300-lb. (300g/m^2 or 640g/m^2) watercolor paper
Others: Pencil, straightedge

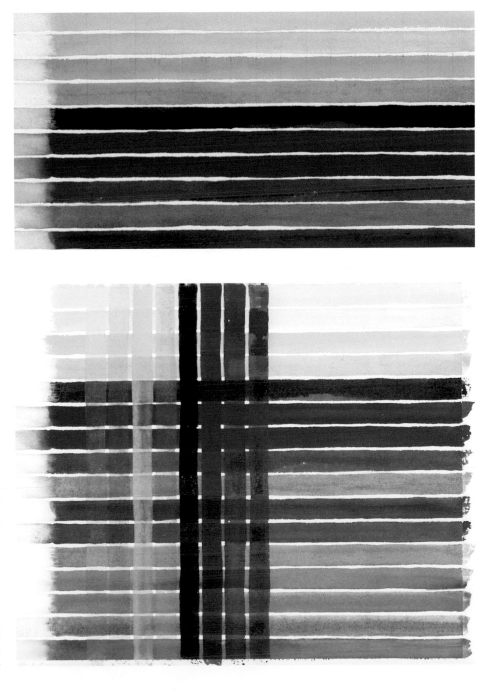

1 PAINT COLORS HORIZONTALLY

Arrange your colors on your palette as in a color spectrum or wheel, and within each primary color from warm to cool. Draw lines about 1″ (2.5cm) apart vertically and horizontally across your paper, one for each color in your palette. Extend the horizontal lines 3″ (7.6cm) longer than the space needed for each of your colors. Horizontally, paint each color between the horizontal lines, leaving about ⅛″ (0.3cm) gap between the colors so they do not run together. Be sure to mix the color with enough water to get a saturated, intense color, but not so thick that you can't see the white paper.

In the extra 3″ (7.6cm) space, paint half with a saturated wash and the other half with a very diluted wash. The diluted wash of each color will provide you with an array of delicate colors to use.

2 PAINT COLORS VERTICALLY

When dry, vertically paint the same colors in the same order. Apply the paint with one stroke, or each brushstroke after the first will lift the layer underneath, and the colors will begin to run together. This exercise teaches you to cover a lot of paper with a fast, but calculated, smooth stroke.

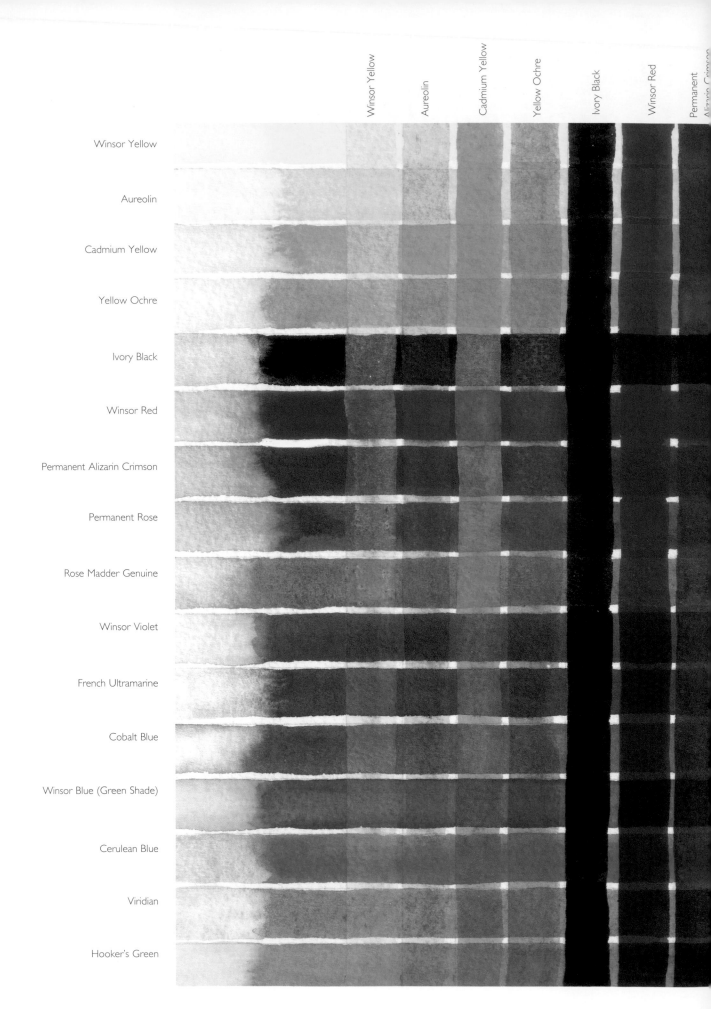

Winsor Yellow

Aureolin

Cadmium Yellow

Yellow Ochre

Ivory Black

Winsor Red

Permanent Alizarin Crimson

Winsor Yellow

Aureolin

Cadmium Yellow

Yellow Ochre

Ivory Black

Winsor Red

Permanent Alizarin Crimson

Permanent Rose

Rose Madder Genuine

Winsor Violet

French Ultramarine

Cobalt Blue

Winsor Blue (Green Shade)

Cerulean Blue

Viridian

Hooker's Green

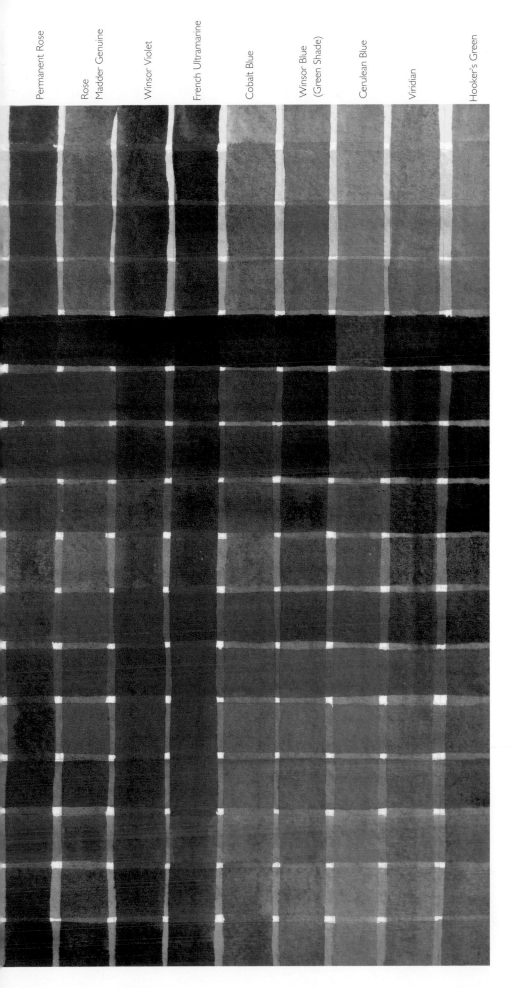

Color Chart for Brilliant Watercolors
Use this chart to understand the colors you use in your paintings. See how each color appears by itself or applied over each other color. Be sure to arrange the colors gradually from warm to cool.

You can make a color chart as large or small as you wish. This chart contains sixteen of the colors I use most often. Since I use very few opaque colors, the Cadmium Yellow stands out the most against the darker colors. Yellow Ochre is opaque, but very weak, so it does not show up as much. Cerulean Blue is also opaque.

Color Temperature

Another important characteristic of color is *temperature*, or whether it is warm or cool. If you look at a simple color wheel, the warm colors are red, orange and yellow; the cool colors, such as violet, blue and green, have blue in them. Think of the hot orange colors of fire and the cold blue of ice. Generally, warm colors sizzle, making us feel warmer or arousing emotion. On the other hand, cool colors calm.

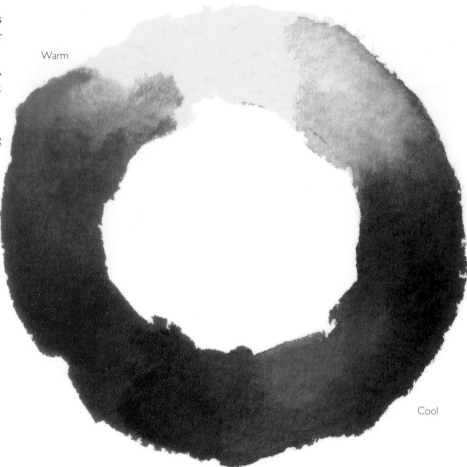

Warm

Cool

Color Temperature

In a simple color wheel, the half of the wheel centered at orange is the warm side and the half of the wheel centered at blue is the cool side. Reds nearer to orange are the warm reds; reds nearer to blue are cool reds. Likewise, yellows nearer to blue are cool yellows; yellows nearer to orange are warm yellows. Since blue is cool, you could consider either reddish blue or yellowish blue to be warmer.

Transparent, Semi-Transparent, Opaque and Semi-Opaque

One of the most critical watercolor characteristics is *transparency/opacity*. Because pigments differ in the amount of white paper they allow to show through, I separate *transparent*, *semi-transparent*, *opaque* and *semi-opaque* colors on my color wheel (pages 50-51). The distinctions between these terms are disputable, but it is helpful for me to think about them this way.

Various watercolor books' designations of colors as transparent and opaque are confusing. One author calls a color opaque; another calls it transparent. On the other hand, manufacturers are careful to point out that transparency is scientifically discernible by chemical composition: Pigments made with cadmium are very opaque, synthetic or organic pigments are transparent, and pigments made with minerals are semi-transparent or opaque. But most artists are not chemists. We must use our vision and experience to determine transparency or opacity.

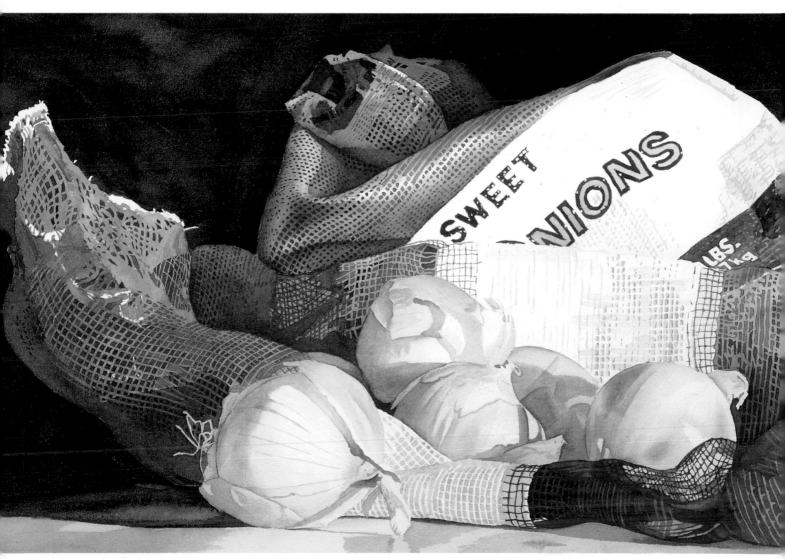

A Glowing Brilliance
The simple subject of *Sweet Onions* belies the power of this painting, as well as the fascinating quality of the see-through red mesh bag. White paper glowing through the transparent colors makes the red seem more brilliant. The onion skins have a translucent quality from the delicate transparent colors. Even the dark burgundy background is not a black hole. It is transparent enough to see through to the white paper.

SWEET ONIONS
13″×20″ (33cm×50.8cm)
Private collection.

Transparent Colors Glow Like Jewels

Like the pure colors of the rainbow, transparent colors used alone give the most brilliant colors. This is because they are the clearest—you can see through them to the white paper. When you paint, light rays go through transparent pigment, and the white paper shines with brilliance. When you paint a transparent color over another color, the bottom color still shows through, clear and strong. When you wash out transparent colors in clear water, the water stays clear but is tinted.

Think of your transparent watercolor pigments as stained glass, and the white paper as the light shining through the glass. Like sunshine through stained glass, the white paper gives a power surge to your color!

Opaque Colors Stop the Glow

Light rays cannot penetrate opaque pigment to get the power surge from the white paper, so opaque colors are less jewel-like. They appreciably obscure and dull the surface so you cannot see the white paper; painting an opaque color over another color diminishes the bottom color. When you wash out opaque colors in clear water, the pigment clouds the water.

An opaque color is less brilliant than a similar transparent color, so reserve opaque colors for areas where they are needed to achieve a certain effect. Opaque colors may be powerful: They are sometimes very useful, and occasionally only an opaque color will do the job. For instance, a powerful opaque Cadmium Yellow was the exact color needed for the inside of the tulips in *Ribbon Quilt With Tulips* (page 92).

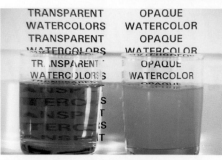

Transparent and Opaque Pigments

To get a feel for transparent and opaque pigments, observe the water in which you rinse out your brushes. On the left, washing a brush with transparent Winsor Blue leaves tinted but clear water. You can see the printing on the paper behind the glass through the transparent pigment. Transparent color has a similar effect on your paper, allowing the white paper to glow through the paint for brilliant color.

On the right, rinsing out a brush with opaque Cerulean Blue clouds the water, and you cannot see through to the printing behind. Opaque colors react similarly on your paper, dulling the surface so light cannot reflect off the white paper beneath it.

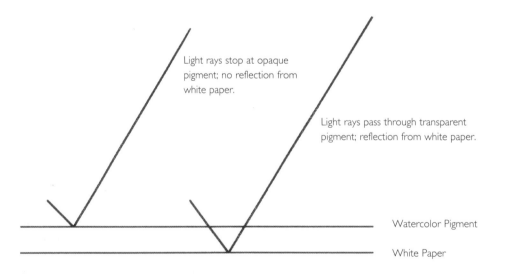

Light rays stop at opaque pigment; no reflection from white paper.

Light rays pass through transparent pigment; reflection from white paper.

Watercolor Pigment

White Paper

Light Rays Reflect White Paper

White paper gives the glow to watercolors. Light rays reflect brilliance from white paper. Light passes easily through transparent pigments and reflects off the white paper. However, opaque pigments stop the light rays so we cannot see the white paper underneath.

Transparent or Opaque?

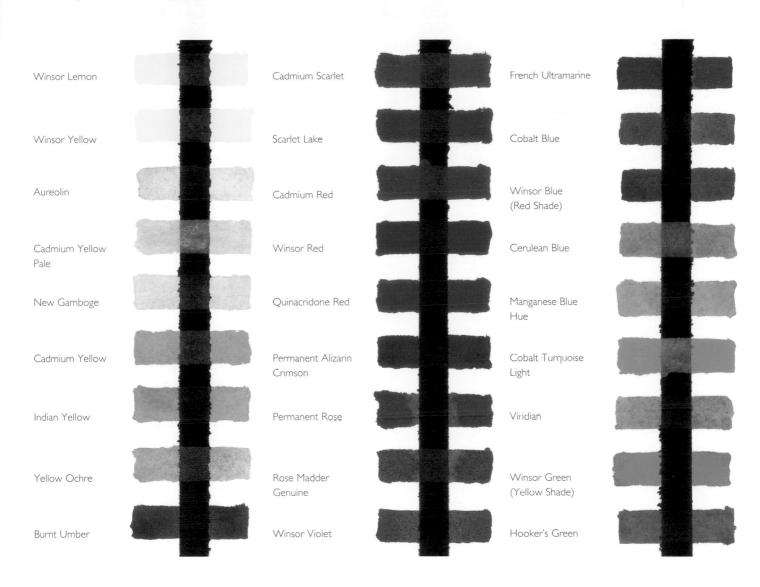

Winsor Lemon	Cadmium Scarlet	French Ultramarine
Winsor Yellow	Scarlet Lake	Cobalt Blue
Aureolin	Cadmium Red	Winsor Blue (Red Shade)
Cadmium Yellow Pale	Winsor Red	Cerulean Blue
New Gamboge	Quinacridone Red	Manganese Blue Hue
Cadmium Yellow	Permanent Alizarin Crimson	Cobalt Turquoise Light
Indian Yellow	Permanent Rose	Viridian
Yellow Ochre	Rose Madder Genuine	Winsor Green (Yellow Shade)
Burnt Umber	Winsor Violet	Hooker's Green

To test your palette colors for transparency and opacity, paint several bands of waterproof black ink on 140- or 300-lb. (300g/m² or 640g/m²) paper with an inexpensive Japanese ink brush. (Never use your good watercolor brushes with ink.) Use drafting tape to make straight lines. When completely dry, paint a small swatch of an intense wash of each of your palette colors over the ink band with a no. 5 round or ½″ (12mm) flat sable brush. Transparent colors allow the black ink to shine through; opaque colors dull the black color appreciably. The black ink is not able to shine through opaque colors.

This chart helps you see the difference between transparent and opaque colors. For instance, Cadmium Yellow shows up when painted over black; Winsor Yellow does not. Choose transparent colors to make your watercolors glow, and reserve opaque colors for specialized uses. Some transparent colors are Winsor Yellow, Aureolin, Hooker's Green, Winsor Blue, French Ultramarine, Winsor Violet, Permanent Alizarin Crimson and Winsor Red.

Here I tested twenty-seven colors for transparency and opacity. Of course, my palette does not normally include very many opaque colors. The opaque colors included here are Cadmium Yellow Pale, Cadmium Yellow, Yellow Ochre, Cadmium Scarlet, Cadmium Red, Cerulean Blue and Cobalt Turquoise Light.

Staining Colors Stick, Nonstaining Colors Lift Easily

Life as a watercolorist is easier when you understand the difference between *staining* and *nonstaining* colors. In one of my earliest watercolors, after painting a horseman with his horse, I washed a staining Sap Green into the background. It overpowered the foreground. I tried everything to tone it down and wash it out, but nothing worked. In desperation I painted white gesso over the offending green, then softened it with watercolor and pastels. It was a memorable lesson in the hazards of staining colors.

A nonstaining pigment can be removed from your paper with a little water and gentle scrubbing. I generally select nonstaining colors if there is one that will do the job. They include Aureolin, Yellow Ochre, Burnt Umber, Rose Madder Genuine and French Ultramarine. It is a good idea to choose nonstaining colors, especially at the beginning of a painting or where you are feeling your way along. That way, you can easily remove the paint if you get too much of a good thing!

However, some of the most gorgeous and vibrant colors are staining, and are difficult, if not impossible, to remove from your paper. For example, Winsor Blue (Green Shade) and Permanent Alizarin Crimson are staining colors and shine like jewels. Cadmium Yellow, an intense, lively yellow, is also staining. You want to take advantage of *all* the beautiful colors available. The main point is to know which colors are staining and to use them with discretion to enliven your paintings.

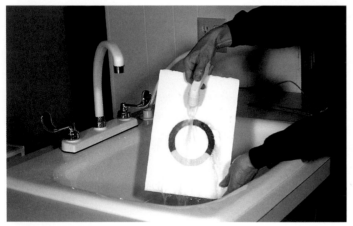

Spray Paint Away

Use the spray attachment on a faucet to spray the area where you want to remove the watercolor paint. If you have a large painting that has gone awry, take it outside and spray it with a garden hose. This is not a place for finesse! First you need to loosen the paint, and then spray directly to remove it. Take care not to disturb the surface of the paper.

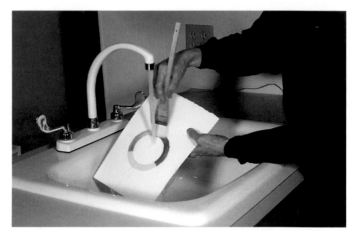

Brush and Spray Paint Away

If spraying the paper does not remove enough pigment, *gently* scrub the paint with a soft hake brush. You can even scrub the paint with the soft brush while spraying it to loosen more pigment. Be careful not to disturb the tooth of the paper. I do not recommend scrubbing with anything other than a very soft hake brush.

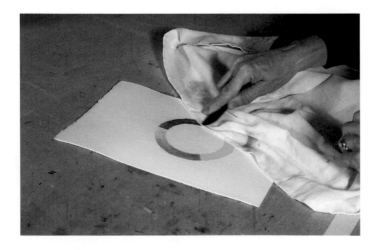

Lift Paint Away

For a small area, or if spraying has not removed enough paint, paint generous amounts of clear water over the pigment to be removed. Place a soft cotton cloth over the top and, using the beveled end of an aquarelle brush, apply pressure to the cloth to lift as much pigment as possible, being careful not to disturb the tooth of your paper. This can be repeated indefinitely—lifting, not rubbing.

Aureolin

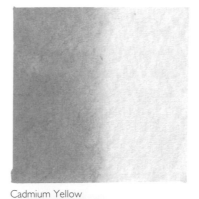

Cadmium Yellow

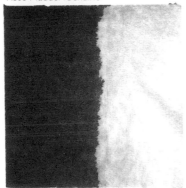

Rose Madder Genuine

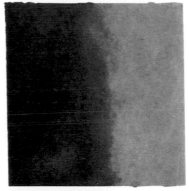

Permanent Alizarin Crimson

French Ultramarine

Winsor Blue (Red Shade)

Viridian

Hooker's Green

Staining and Nonstaining Colors

A simple test helps you discover the staining colors of your palette before they overpower your painting. Paint a square of color on 300-lb. (640g/m²) paper with a no. 5 round or ½″ (12mm) flat sable brush. Then press a burnishing tool (the end of a 1″ [25mm] aquarelle brush is perfect) into a clean, smooth cotton or paper towel to lift the color from one-half of the area. Use a soft, flat brush to scrub with clean water, and lift again with the towel and burnisher. If the pigments lift easily, it is a nonstaining color. The more pigment that remains in the paper, the more staining the color.

Here I test staining and nonstaining yellows, reds, blues and greens from my palette. The staining colors are Cadmium Yellow, Permanent Alizarin Crimson, Winsor Blue (Red Shade) and Hooker's Green. Be sure of what you are doing before you paint with these colors, because it will be hard to change your mind later. I was able to easily remove from the white paper almost all of the pigment from the nonstaining colors, Aureolin, Rose Madder Genuine, French Ultramarine and Viridian.

Powerful Colors Go a Long Way; Delicate Colors Add Subtle Changes

As you paint, you will become aware that some colors are more powerful than others. It became obvious to me the first time I squeezed out Winsor Blue on my palette to make a purple mix. I wanted to make sure I mixed enough paint to cover a very large area of paper. By the time I added enough Permanent Alizarin Crimson to make purple, I had enough to paint my studio wall as well!

Powerful colors need only a small amount of pigment to affect the color, whereas weaker colors need a lot of pig-ment to appreciably affect the color.

You need to know which colors are powerful when you choose and mix colors. Just a touch of these potent colors will tint your mix; more will dominate it.

If you choose weaker colors, be aware that it takes a lot of these colors to change the look of a more powerful color. If you want subtle colors in your painting, choose delicate pigments. For instance, in *Joyful Faces* (page 32) the pink roses and the centers of the pink dahlias are almost white; just a touch of a delicate Rose Mad-der Genuine makes these exquisite soft pinks.

Knowing the carrying power of the color will help you to select not only the right color, but also the right amount of pigment to use in making mixes. Color use will become intuitive with practice. Using the right amount of pigment saves time and paint and ensures that you will not overpower your painting with one of these strong colors.

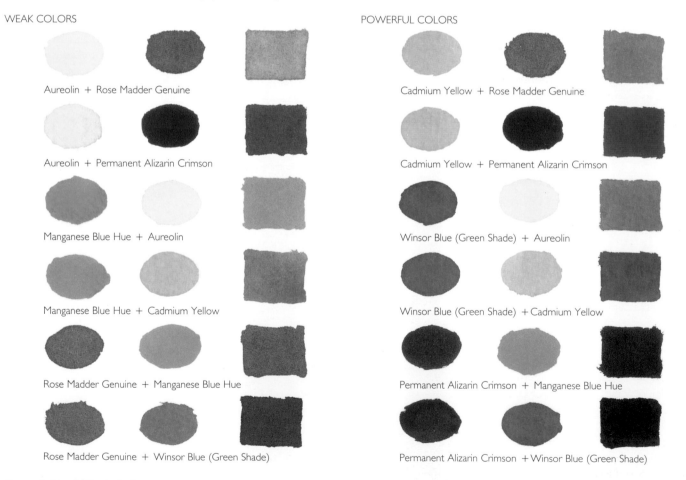

WEAK COLORS

Aureolin + Rose Madder Genuine

Aureolin + Permanent Alizarin Crimson

Manganese Blue Hue + Aureolin

Manganese Blue Hue + Cadmium Yellow

Rose Madder Genuine + Manganese Blue Hue

Rose Madder Genuine + Winsor Blue (Green Shade)

POWERFUL COLORS

Cadmium Yellow + Rose Madder Genuine

Cadmium Yellow + Permanent Alizarin Crimson

Winsor Blue (Green Shade) + Aureolin

Winsor Blue (Green Shade) + Cadmium Yellow

Permanent Alizarin Crimson + Manganese Blue Hue

Permanent Alizarin Crimson + Winsor Blue (Green Shade)

Powerful and Weak Colors

Take a few minutes to determine the relative power or weakness of your colors. Select two colors, mix equal amounts together and observe the results. This gives a feel for which pigments are powerful and which are weak.

I chose weak and strong yellows, reds and blues, and mixed them alternately with weak and strong colors. Just a touch of a powerful color changes another color. However, you need a lot of a weak color to make an appreciable difference in any but another weak color. Keep in mind whether a color is powerful or weak in your selection of colors, as well as in gauging the amount of color to mix with another.

Granulated Colors Give Texture; Nongranulated Colors Are Smooth

Some watercolor pigments create marvelous granular textures. This characteristic has less to do with color mixing and more to do with the appearance of the paint. Some pigments are *granulated*, and some are smooth. The pigment of granulated colors settles into the low spots of the paper, giving a grainy appearance to the painting. This granulated quality is more obvious with rougher textured paper (something to keep in mind if you paint with rough paper, as I do). The pigment in smooth colors is equally dispersed for a solid, flat color.

In *Joyful Faces* (page 32), granulated pigments, especially in the quilt blocks, add textural interest to the different kinds of fabric and keep the quilt from having a flat, "paint-by-numbers" appearance. Manganese Blue Hue adds an especially rich appearance to the painting.

Granulated and Smooth Colors

The pigment of granulated colors settles into paper crevasses, making darker spots and uneven coloration. Pigment of smooth colors evenly disperses and makes an even color on any paper. Knowing the difference between pigments can help you make the most advantageous choice of color. Be careful not to use a granulated color if you desire a smooth surface.

To determine if a color is granulated, paint a square of the color, trying to make the color as even as possible. Let it dry. Granulated colors included here are Manganese Blue Hue, Raw Umber, Cerulean Blue, Cadmium Red, Cobalt Blue, Rose Madder Genuine and Cobalt Violet.

Winsor Yellow

Manganese Blue Hue*

Raw Umber*

Cerulean Blue*

Cadmium Red*

Winsor Blue (Green Shade)

Winsor Red

Cobalt Blue*

Permanent Rose

Winsor Violet

Rose Madder Genuine*

Cobalt Violet*

*Indicates granulated color

Make a Color Wheel

A color wheel shows at a glance the relationships between colors. Use your color chart to help you place colors on a wheel. I separate transparent, semi-transparent, opaque and semi-opaque colors on my color wheel. These distinctions are debatable, but it is helpful for me to think about colors in this way. I devised this color wheel to help explain how to select brilliant colors. Use the colors on your palette (or mine) to help make your own color wheel.

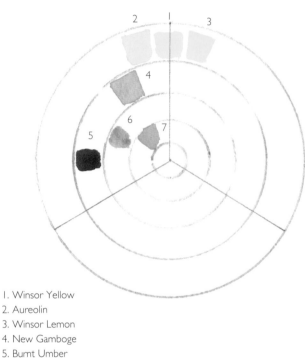

1. Winsor Yellow
2. Aureolin
3. Winsor Lemon
4. New Gamboge
5. Burnt Umber
6. Yellow Ochre
7. Cadmium Yellow

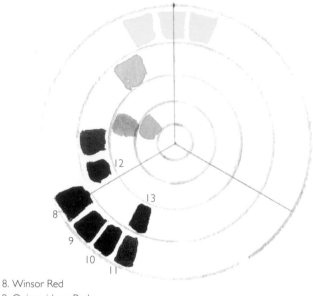

8. Winsor Red
9. Quinacridone Red
10. Permanent Alizarin Crimson
11. Rose Madder Genunie
12. Scarlet Lake
13. Permanent Rose

1 BEGIN YOUR COLOR WHEEL

Draw five concentric circles on a sheet of 15″×18″ (38.1cm×45.7cm) watercolor paper using a compass or circle templates. The outer circle should be about 11½″ (29.2cm) in diameter, the inner one about 2½″ (6.4cm) in diameter. Divide the wheel into three equal sections by drawing lines from the center to the outside edge, starting at the top.

Using your color chart as a guide, place your palette yellow shades on your color wheel with the transparent colors on the outer ring. Use your color chart to arrange each color from warm to cool. Place the truest (neither warm nor cool) yellow, like Winsor Yellow, on the line at the top in the outer ring. Then place the other yellows in their positions, with increasingly warm (orange) yellows, like Aureolin, to the left, and increasingly cool (green) yellows, like Winsor Lemon, to the right. New Gamboge and Burnt Umber show up slightly over dark colors on the color chart, so place them on the second ring, semi-transparent. Yellow Ochre shows more substantially over dark colors. Place it on the third ring, semi-opaque. Finally, Cadmium Yellow shows up clearly when painted over dark colors, so place it on the fourth ring, opaque.

2 PLACE YOUR REDS

Now place your palette reds on your color wheel, with the truest transparent red, like Winsor Red, on the line in the outside ring. Place increasingly warm reds (orange) toward the yellow, and increasingly cool reds, such as Quinacridone Red, Permanent Alizarin Crimson and Rose Madder Genuine, toward the blue side. Place semi-transparent reds, such as Scarlet Lake and Permanent Rose, in the second ring. My palette does not include semi-opaque or opaque reds. If your palette does, place semi-opaque reds, such as Light Red, in the third ring. Place opaque reds, like Cadmium Red or Vermilion, in the fourth ring.

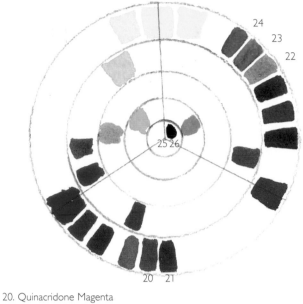

14. French Ultramarine
15. Winsor Blue (Red Shade)
16. Prussian Blue
17. Winsor Blue (Green Shade)
18. Cobalt Blue
19. Cerulean Blue

20. Quinacridone Magenta
21. Winsor Violet
22. Viridian
23. Winsor Green (Yellow Shade)
24. Hooker's Green
25. Chinese White
26. Ivory Black

3 PLACE YOUR BLUES

Put your palette blues on your color wheel, with the truest transparent blue, such as French Ultramarine, on the line on the outside ring. Situate increasingly reddish blues toward the red and increasingly yellowish blues, such as Winsor Blue (Red Shade), Prussian Blue and Winsor Blue (Green Shade) toward the yellow. Arrange each blue according to its transparency on the four outer rings, with Cobalt Blue in the semi-transparent (second) ring, and Cerulean Blue in the opaque (fourth) ring. If you use a semi-opaque blue such as Indigo, place it in the semi-opaque (third) ring.

4 PLACE YOUR SECONDARY COLORS

Place your palette secondary colors (green, orange and violet) on the wheel in the same way you placed the primary colors, from warm to cool and from transparent to opaque. I insert Quinacridone Magenta and Winsor Violet on the transparent ring between red and blue. Viridian, Winsor Green (Yellow Shade) and Hooker's Green belong between blue and yellow in the transparent ring. Finally, add white and black, such as Chinese White and Ivory Black, to the center, if you use them. I seldom use either.

MATERIALS LIST

Paint: All the colors on your palette
Brush: no. 5 sable or ½″ (12mm) flat
Paper: 140-lb. or 300-lb.
(300g/m² or 640g/m²) watercolor paper
Other: Circle templates or compass

Color Wheel for Brilliant Watercolors

For a fuller understanding of all the colors available and the choices we make, the *Color Wheel for Brilliant Watercolors* shows a full range of colors. You can make a similar wheel using any colors or brands of paint.

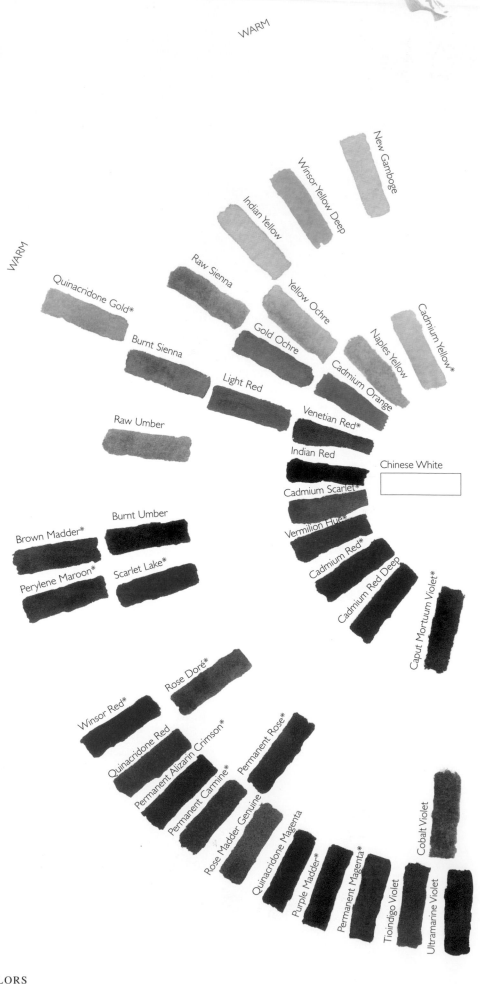

WARM

WARM

New Gamboge

Winsor Yellow Deep

Indian Yellow

Raw Sienna

Yellow Ochre

Cadmium Yellow*

Naples Yellow

Quinacridone Gold*

Gold Ochre

Cadmium Orange

Burnt Sienna

Light Red

Venetian Red*

Raw Umber

Indian Red

Chinese White

Cadmium Scarlet*

Burnt Umber

Vermilion Hue*

Brown Madder*

Cadmium Red*

Perylene Maroon*

Scarlet Lake*

Cadmium Red Deep

Caput Mortuum Violet*

Rose Dore*

Winsor Red*

Permanent Rose*

Quinacridone Red

Permanent Alizarin Crimson*

Permanent Carmine*

Permanent Magenta

Cobalt Violet

Rose Madder Genuine

Quinacridone Magenta

Purple Madder*

Permanent Magenta*

Tioindigo Violet

Ultramarine Violet

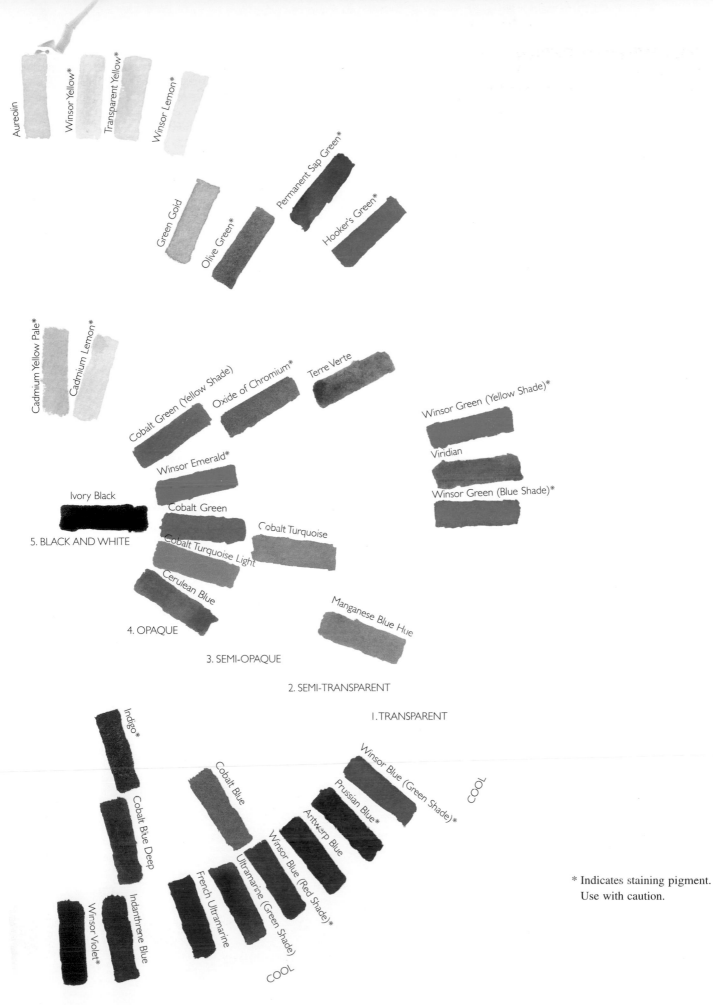

Aureolin

Winsor Yellow*

Transparent Yellow*

Winsor Lemon*

Green Gold

Olive Green*

Permanent Sap Green*

Hooker's Green*

Cadmium Yellow Pale*

Cadmium Lemon*

Cobalt Green (Yellow Shade)

Oxide of Chromium*

Terre Verte

Winsor Green (Yellow Shade)*

Viridian

Winsor Green (Blue Shade)*

Winsor Emerald*

Ivory Black

Cobalt Green

Cobalt Turquoise

5. BLACK AND WHITE

Cobalt Turquoise Light

Cerulean Blue

4. OPAQUE

Manganese Blue Hue

3. SEMI-OPAQUE

2. SEMI-TRANSPARENT

1. TRANSPARENT

Indigo*

Cobalt Blue

Winsor Blue (Green Shade)*

Cobalt Blue Deep

Prussian Blue*

Antwerp Blue

COOL

Winsor Blue (Red Shade)*

Winsor Violet*

Indanthrene Blue

French Ultramarine

Ultramarine (Green Shade)

COOL

* Indicates staining pigment.
Use with caution.

summary and tips

1. Use a *color chart* to see whether a color is transparent or opaque, warm or cool.

2. Use a *color wheel* to see how one color relates to other colors.

3. Arrange colors on your palette like a color wheel.

4. Use transparent colors straight from the tube for the greatest brilliance.

5. Remember: Warm colors sizzle; cool colors calm.

6. Staining colors enliven *and* they stick where you paint them.

7. Know the carrying power of your colors to help you select the right color and mix correctly.

8. Give texture to your paintings by selectively using granulated colors.

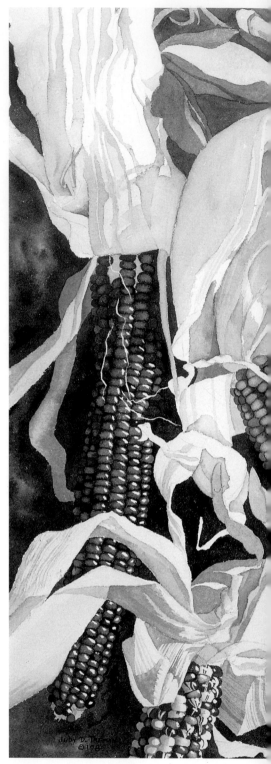

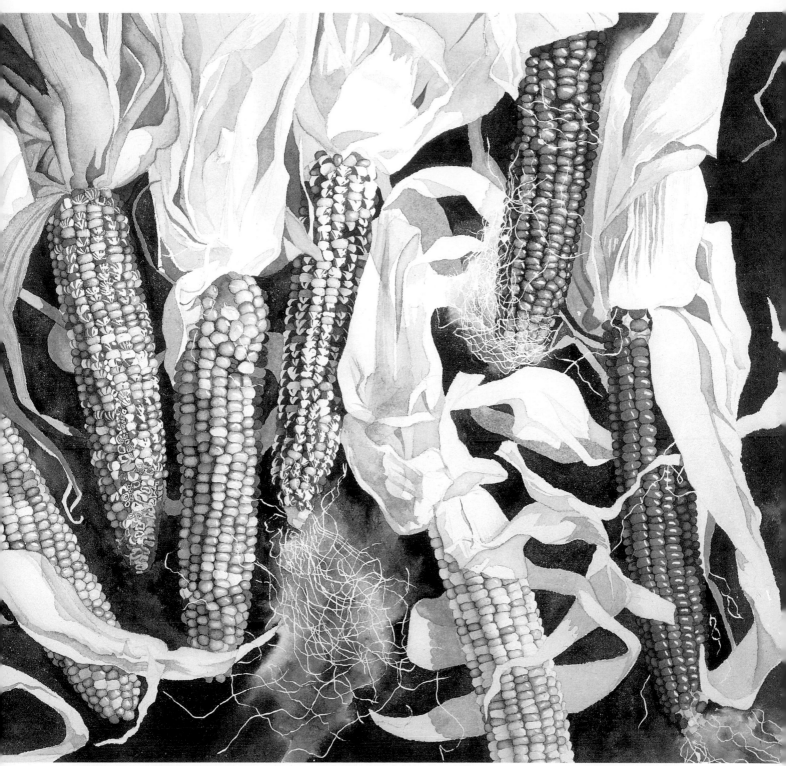

Transparent Colors Glow

Transparent colors give *The Wild Bunch* its glow. There are no opaque colors in the painting. Most colors are taken directly from the outer (transparent) ring of the color wheel or are mixes of adjoining transparent colors. The painting uses warm colors (reds and yellows) extensively. The few cool blue kernels act as a catalyst for the warm colors, making them more emphatic.

THE WILD BUNCH
16″ × 24″ (40.6cm × 61cm)
Collection of the artist.

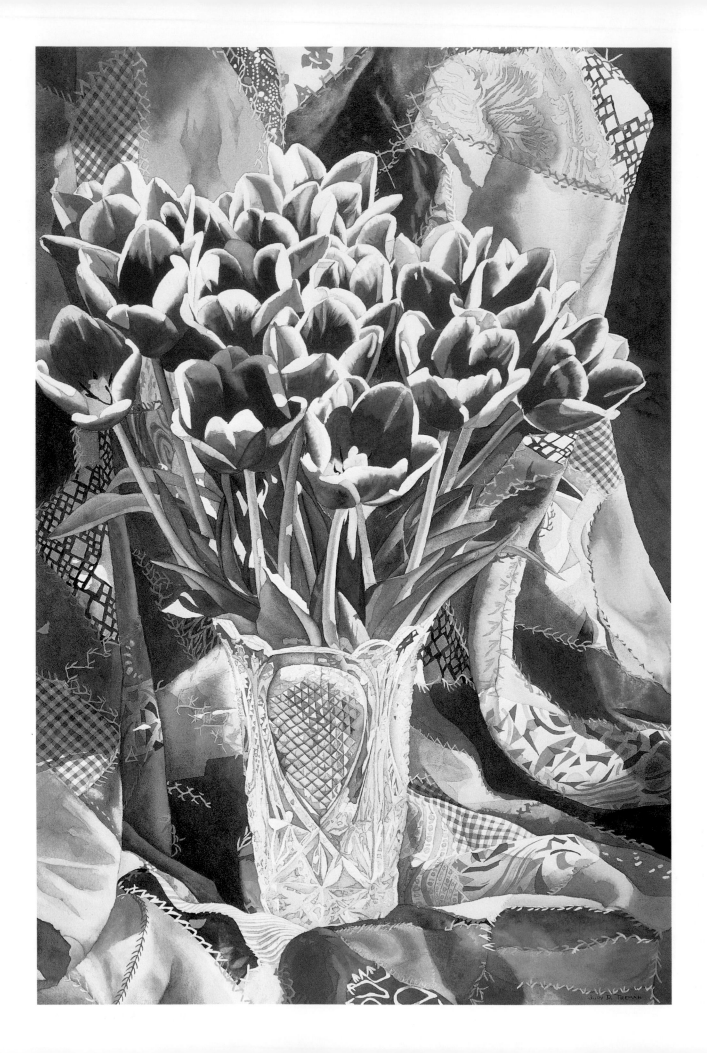

Make the Most of Color

When I began feeling my way with watercolor, I used soft earth tones. Living with gray days for many years in the Pacific Northwest, muted colors seemed natural. Then I made several trips to the Southwest, where I saw bold colors, and each time upon returning I doubled the color in my paintings.

As my understanding and confidence grew, I gradually increased the vibrancy of my colors; now I rarely use earth colors. My paintings are celebrations of life, and I want ever-larger and more colorful celebrations.

The American Watercolor Society in New York included my painting *Simple Joys—Amish Sampler* (page 97 and cover) in an exhibition several years ago. I was surprised by people searching me out to see for themselves the small, soft-spoken woman who painted the large, colorful flowers. The author of a book on color remarked to me that she did not know how I used so much color and yet made it work as a painting. That is the trick!

JOIE DE VIVRE
39″ × 26″ (99.1cm × 66cm)
Private collection.

Brilliant Colors Hold Their Own

This sumptuous mass of brilliant pink-and-white tulips holds its own without being overwhelmed by the colors and patterns of my favorite silk quilt. The most intense colors are fittingly in the tulips radiating their message of joy. Softer colors in the background quilt help achieve a feeling of depth. The most vivid color in the quilt is the red in the foreground. The quilt colors are clear and bright, even in the shadows. These shadows are not black holes, but are alive with color. Delicate colors carefully delineate designs in the cut glass vase. The dominating size of the painting increases its impact. The tulips are more than twice life-size. The impact of all the colors is very powerful.

Mix Vibrant Colors

Even with all the tube colors available, many of the colors we want don't come straight from the tube, so we need to mix colors together. Three simple rules of thumb will help you select the most useful colors to mix brilliant, jewel-tone colors.

The Fewer Colors the Better
The first rule of thumb to achieve brilliant color is the fewer colors you mix together, the clearer and brighter your color will be. A single tube color has the most vibrant color. The more colors you mix together, the less clarity your colors have.

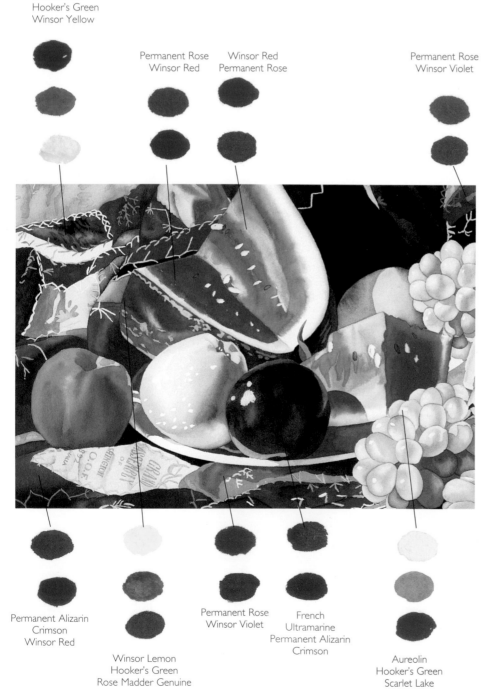

Winsor Red
Hooker's Green
Winsor Yellow

Permanent Rose
Winsor Red

Winsor Red
Permanent Rose

Permanent Rose
Winsor Violet

Permanent Alizarin
Crimson
Winsor Red

Winsor Lemon
Hooker's Green
Rose Madder Genuine

Permanent Rose
Winsor Violet

French
Ultramarine
Permanent Alizarin
Crimson

Aureolin
Hooker's Green
Scarlet Lake

Color-Mixing Study
This study of vibrant color mixes indicates several of the tube color mixes I use to obtain vivid color. Transparent pigments are one reason for the jewel-like colors. They allow white paper to give its power boost to the colors. The color used in the greatest quantity is shown nearest the painting. Most frequently I mix two adjoining transparent colors. For greens, I use three— yellow and a minuscule amount of red to naturalize tube greens.

Lessen a color's intensity by adding more water. It is a good idea to mix a range of intensities by adding various amounts of water. This allows for variations of color within each part of the painting and makes the painting more vibrant than if each grape was painted a flat green, or the watermelon a flat red.

Mix Transparent Colors Whenever Possible

The second rule of thumb to achieve brilliant color is to choose and mix transparent pigments from the outer ring of your color wheel. You can easily combine transparent pigments to make jewel-like colors. You can mix a transparent color with an opaque color with less clear results, and as you add opaque colors, the likelihood of mud increases! Mixing two or more opaque colors quickly gets you into murky territory, so exercise caution. Use opaque colors from the inner ring of your color wheel with discretion, and only when you cannot figure out some other way to get the color you want.

MAKING BRILLIANT MIXTURES

The most brilliant mixes are *adjoining, transparent* colors—the *fewer* the better.

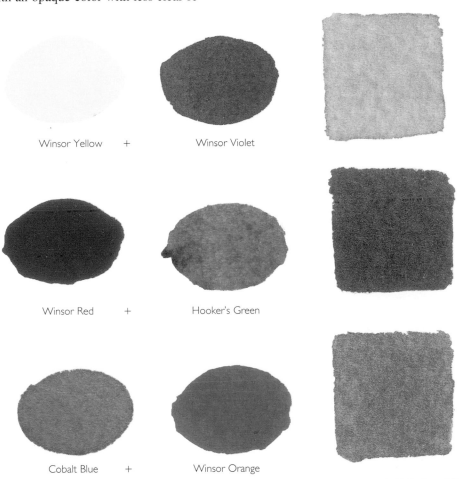

Winsor Yellow + Winsor Violet

Winsor Red + Hooker's Green

Cobalt Blue + Winsor Orange

Mixing Transparent and Opaque Colors

Mix transparent colors for more vibrant colors. Complementary colors are opposites on the color wheel, and mixing opposites results in gray. The first two mixtures of transparent colors are clear, lively grays; the third mixture, of semi-transparent Cobalt Blue and opaque Winsor Orange, makes a dull, muddy gray.

Mix Adjoining Colors on the Color Wheel

The third rule of thumb to achieve brilliant color is to choose and mix adjoining colors, ones that are close to each other on your color wheel. The farther apart the colors are on the color wheel, the grayer the color. If you mix exact opposite colors (complementary colors), such as yellow with purple, the result is gray, as shown on page 57.

Another way to think about adjoining colors is to see that cool colors and warm colors are each grouped together on the color wheel. Then, if you want to make a clear orange, mix a warm yellow and a warm red that are close together on the color wheel. If you mix a cool yellow and a cool red, which are farther apart on the color wheel, the color is much less brilliant. A clear green is a mix of a cool yellow and a cool blue. A cool red and a reddish blue make a vibrant purple.

KEEP THE GLOW

While it may be intoxicating to use brilliant color, do not forget to let the white paper glow through the pigment.

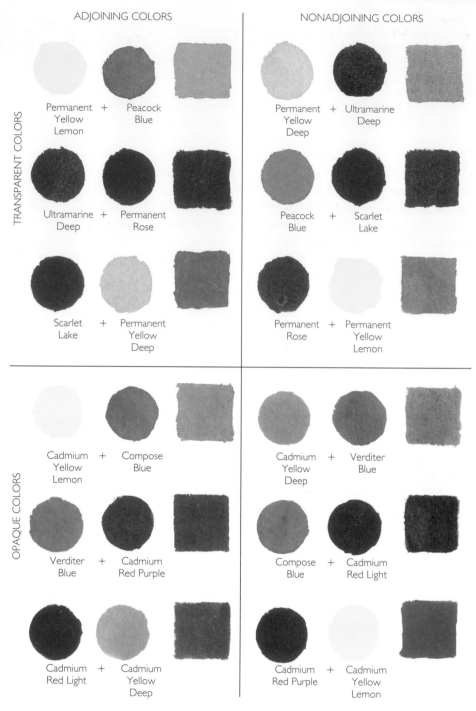

ADJOINING COLORS

Permanent Yellow Lemon + Peacock Blue

Ultramarine Deep + Permanent Rose

Scarlet Lake + Permanent Yellow Deep

NONADJOINING COLORS

Permanent Yellow Deep + Ultramarine Deep

Peacock Blue + Scarlet Lake

Permanent Rose + Permanent Yellow Lemon

TRANSPARENT COLORS

OPAQUE COLORS

Cadmium Yellow Lemon + Compose Blue

Verditer Blue + Cadmium Red Purple

Cadmium Red Light + Cadmium Yellow Deep

Cadmium Yellow Deep + Verditer Blue

Compose Blue + Cadmium Red Light

Cadmium Red Purple + Cadmium Yellow Lemon

Compare Adjoining and Nonadjoining Transparent and Opaque Colors (Holbein Artist's Watercolors)

Adjoining transparent mixes make brilliant colors. The upper left quadrant's green, violet and orange are clear and bright.

Opaque colors may be powerful alone, but are not as brilliant as similar transparents. Adjoining opaque colors in the lower left quadrant are less brilliant. The green and orange are acceptable colors, but the violet is murky.

Nonadjoining transparent colors in the upper right quadrant are grayed. Nonadjoining opaque colors in the lower right quadrant are both grayed and dull.

Complementary Colors Sizzle or Turn to Mud

Just as mixing nonadjoining transparent colors creates grayed colors, mixing complementary colors, like blue and orange, together results in gray. Predictably, transparent complementary mixes are livelier than opaque ones. Keep the mud out of your watercolors by not mixing complementary colors together, or at least use only a small, carefully measured dose of the complementary.

Although *mixing* complementary colors makes grayed tones, using complementary colors adjacent to each other makes each color more powerful. If you want to emphasize a color, place it next to its complementary color. Reds look redder adjacent to green. In *Joie de Vivre* (page 54), part of the reason the intense pink tulips are so dramatic is they are adjacent to complementary green leaves. Likewise, yellow is a jarring wake-up call next to purple, and orange sizzles against blue.

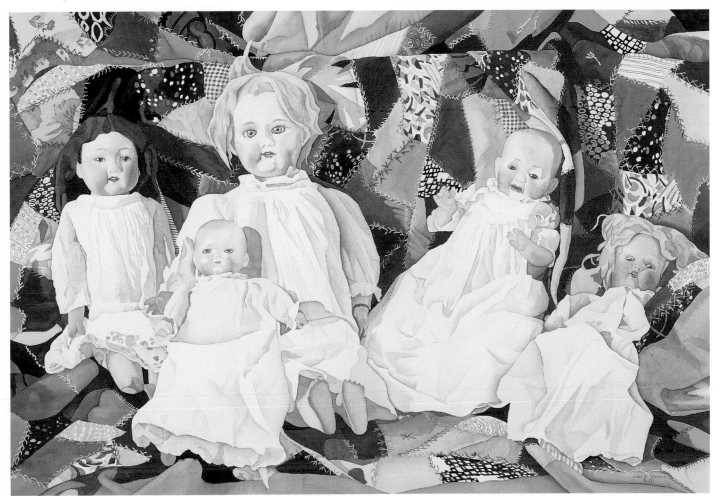

Emphasize Colors With Complements
Complementary colors help to animate *The Girls in White Dresses*, with its delicate, transparent colors. Varying shades of greens are a lively contrast to their complementary pinks, giving depth, excitement and a dynamic quality to the painting. The dolls in their white dresses stand out dramatically and appear to come forward against the colorful background. In spite of the softness of the hues, the painting is dynamic because of the juxtaposition of complementary colors.

THE GIRLS IN WHITE DRESSES
27" × 38¼" (68.6cm × 97.2cm)
Private collection.

Use Warm Colors With Warms, Cool Colors With Cools

Use your color wheel to increase the impact of your painting by using colors from the warm side together and colors from the cool side together. Your painting will be more harmonious and will capture the mood you want. The vibrant reds and yellows in *Kaleidoscope* (below) are compatible because they are relatively warm colors, and they give a sunny mood.

Joyful Faces (page 32) shows effective use of cool colors together. I used many colors in this painting, selected from the cool half of the color wheel so they relate well to each other and work together to create a harmonious whole. Magenta and pink flowers are cool (bluer) reds, and cool blues and violets are used in the background. A vibrant warm orange flower or quilt patch would look out of place and spoil the painting.

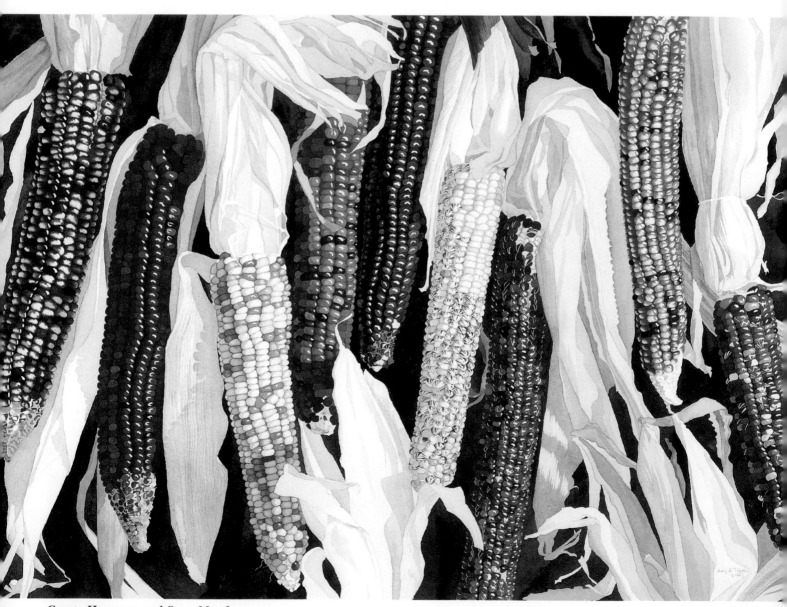

Create Harmony and Set a Mood
At over 2' (61cm) in length, each corn ear is full of pizzazz. A sunny warmth radiates from the red ears of corn in *Kaleidoscope* which go well with warm yellow husks to create a harmonious whole. Most of the colors in this painting come from the warm side of the color wheel.

KALEIDOSCOPE
29″ × 41″ (73.7cm × 104.1cm)
Collection of the artist.

Warm Colors Advance; Cool Colors Recede

Use warm colors to make objects advance toward the viewer and cool colors to make objects recede. You can give a warm color extra punch by juxtaposing a cool color adjacent to it; give your subject matter an extra boost by using warm colors against a cooler background.

In my paintings, I often juxtapose warm flowers against cool background colors to emphasize the subject matter.

This is one of the reasons why the flowers in my paintings often thrust toward the viewer. The warm subject advances and the cool background recedes, giving depth to the painting. Notice some of the warms and cools of the previous chapter. In *Joyful Faces* (page 32), the pink flowers stand out from the relatively cooler blues and greens of the background. The cool blue colors of the quilt recede into the background, pushing the relatively warmer

pink flowers forward. Yellow highlights the tiny quilt stitches and enlivens the painting.

Fandango (below) is a complicated painting. The overall tone is very warm, especially the reddish orange dahlias. Using their cool green-blue complements in the serape accentuates them. It also gives depth to the painting. The play between warm and cool colors is as lively as the Spanish dance that inspired this painting.

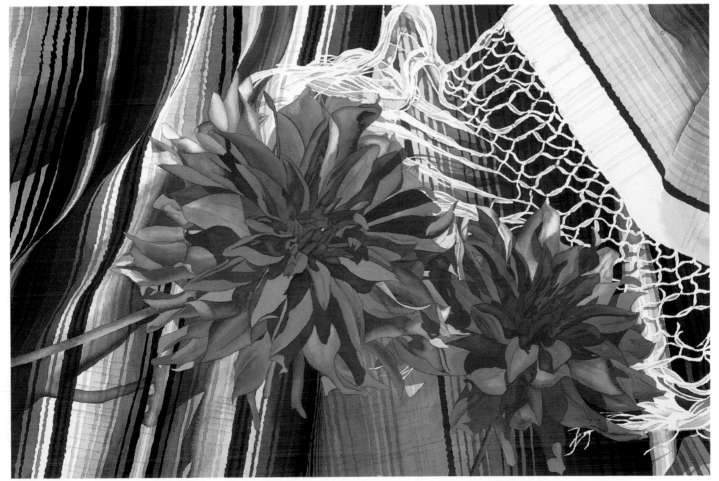

Sizzling Color

With their curling petals and sizzling color, these dahlias remind me of the whirling skirts of Spanish dancers in a fandango. Warm colors come forward, while cool colors retreat. Hot reddish-orange dahlias juxtaposed against cool green and blue stripes in the serape give depth to the painting, as well as an active mood. The eye jumps back and forth between the warm and cool colors and from twisting petals to rolling stripes to fringe. There is a lively, dynamic feeling of perpetual motion, like the lively dance.

FANDANGO
27″ × 39″ (68.6cm × 99.1cm)
Private collection.

Tone Down Tube Greens

One reason I did not paint flowers early in my career is that they have green leaves. Green is one of the hardest colors to paint because it's too easy to get *too* green: Tube greens tend to be very intense and overpowering. For example, I have had some terrible experiences with the very powerful and staining Sap Green. Yet it's very difficult to make a clear green by mixing blue and yellow. This is partly due to the fact that the blues and yellows of the right hues are often opaque colors. I find that I achieve better results by using a transparent tube green and toning it down with other transparent colors.

Winsor Green and Sap Green are usually too strong and staining for my use, and Terra Verte is too weak. I use a mixture of Hooker's Green or Viridian with different yellows, and then add just a touch of red—either Scarlet Lake, Winsor Red or Permanent Alizarin Crimson. Decide if you want a cool or warm green, and then choose colors accordingly. Use warm colors with warm and cool with cool. The exception is if you want a very dull or grayed green, such as some tulip leaves. Then you mix warms and cools on purpose.

Each time you need a green, experiment on your own to see which mix works best. Practice combining the colors so you know how they act together. It often takes a fair amount of yellow and not much red to come up with an acceptable green. With practice, your greens soon will become second nature.

Tube Green	Yellow	Yellow Green

Hooker's Green + Winsor Yellow

Viridian + Winsor Lemon

Winsor Green
(Yellow Shade) + New Gamboge

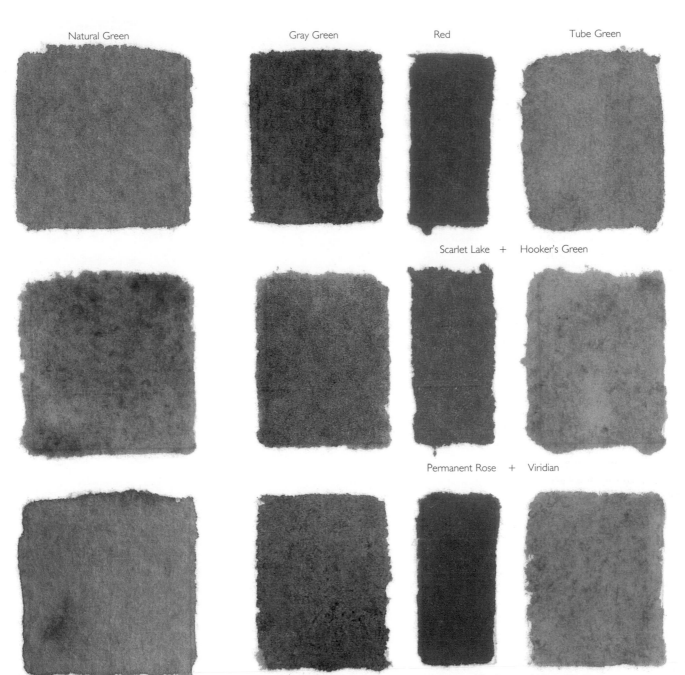

Natural Green Gray Green Red Tube Green

Scarlet Lake + Hooker's Green

Permanent Rose + Viridian

Permanent Alizarin + Winsor Green
Crimson (Yellow Shade)

Mixing Natural Greens

Tube greens are too green for natural-looking leaves. You can mix greens by combining blues and yellows, but a transparent tube green with a little yellow and a touch of red makes a pleasing, not overpowering, green.

Hooker's Green mixed with a clear yellow like Winsor Yellow and a yellowish red like Scarlet Lake makes a clear, warm green. To make a cooler green, use Viridian with Winsor Lemon and Permanent Rose.

Of course, you can adjust the green to be brighter or duller by adding more yellow or red, or more water. The possibilities are endless!

This chart shows a few ways to mix natural-looking greens. On the left are tube green colors mixed with yellow (yellow greens). On the right are tube green colors mixed with red (gray greens). In the center are combinations of the green, yellow and red tube colors. The natural greens are the most useful.

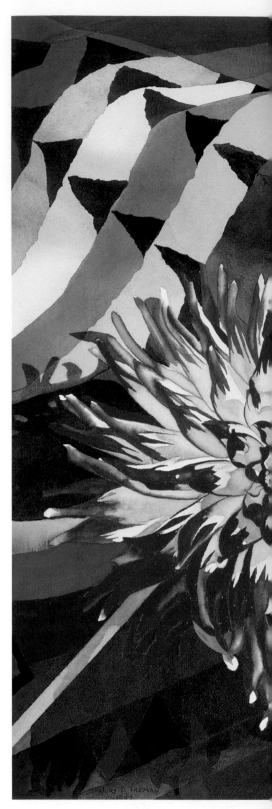

1. Mix fewer colors for clearer and brighter colors—a single color alone is the most brilliant.

2. Mix transparent colors from the outer ring of the color wheel for brilliant color.

3. Mix colors that are close together on the color wheel for brilliant color.

4. Mix complementary colors for gray tones; paint complementary colors beside each other to make both look more vibrant.

5. Create harmony and set a mood by using warm colors together or cool colors together.

6. Contrast warm and cool colors to create excitement; also use warm to advance and cool to recede.

7. Tone down tube greens with transparent yellows and reds.

MONUMENTAL WATERCOLORS ALIVE WITH COLOR

As my fascination with color grows, so does the size of my paintings. My earliest paintings were small and quiet—like I appear on the outside. Over the years my paintings have increased in size, complexity and color— like I feel on the inside. Luckily, manufacturers keep making larger paper. Even at that, I'm champing at the bit for 60″ × 80″ (152.4cm × 203.2cm), 2,228-lb. rough sheets. I just keep wanting more space for all that voluptuous color!

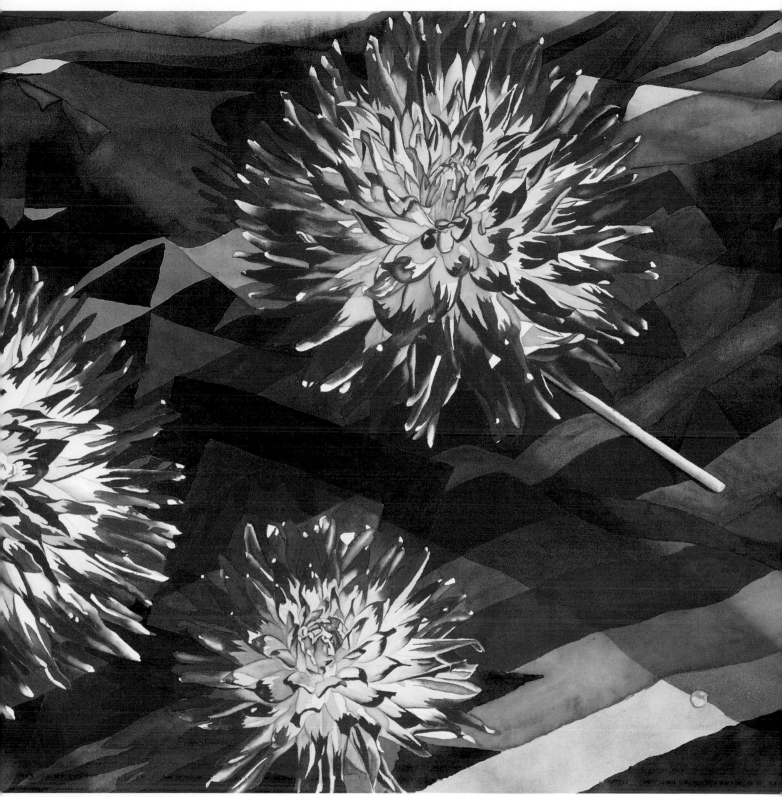

Full Spectrum of Colors

In *Indian Summer II*, showy red- and yellow-spiked dahlias float above the blues and purples of the sensational Indian blanket. These warm, intense blossoms sizzle and move toward the viewer and away from the cool tones of the background blanket. The juxtaposition of complementary colors imparts drama, vibrancy and liveliness. Red and yellow in both the blossoms and blanket tie the foreground and background together. This painting uses to advantage the full spectrum of primary, secondary and complementary colors. Transparent colors impart brilliance!

INDIAN SUMMER II
27″ × 39″ (68.6cm × 99.1cm)
Private collection.

Painting Techniques Enhance Color

EXUBERANCE
39″×59″ (99.1cm×149.9cm)
Collection of the artist.

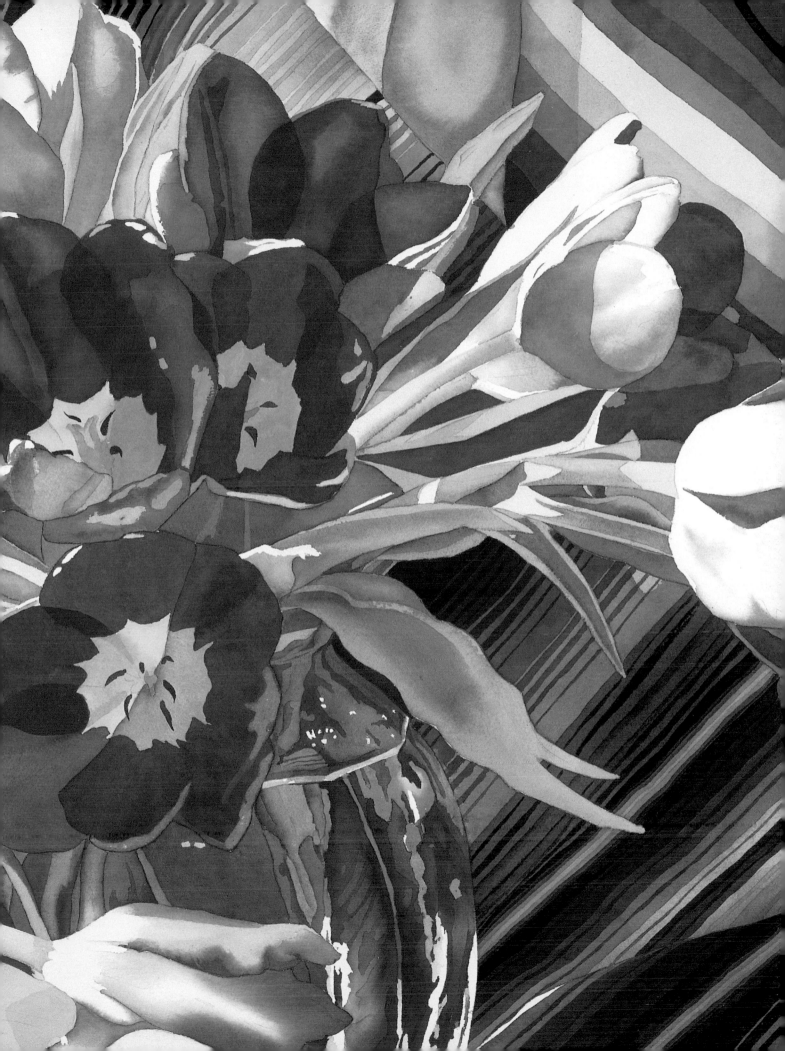

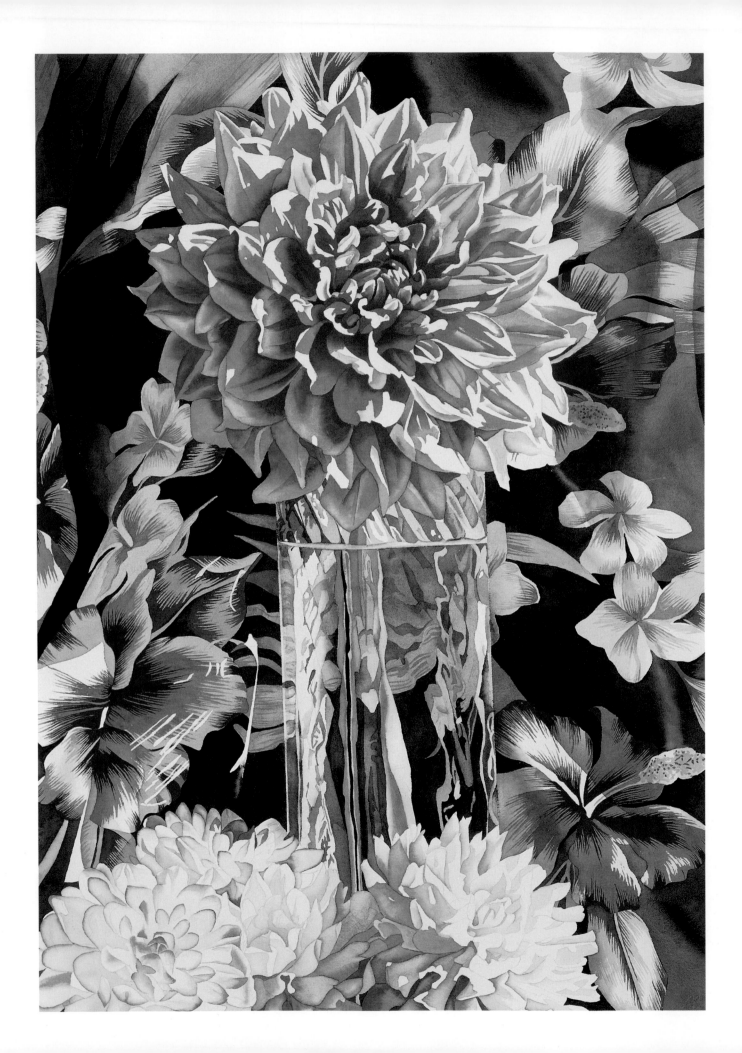

Capture Brilliance With Edges and Washes

Free-flowing spontaneity is one of watercolor's main attractions. You cannot control exactly what watercolor does on paper. Indeed, you would lose part of the beauty if you could control it. You can, however, learn how, when and where to add water and pigment to your paintings to get the effects you want.

Watercolor's fluidity enables you to capitalize on liquid washes of color, as well as the ability to push pigment to form soft and crisp edges, two keys to creating brilliant color. The way you add water to pigment and paper determines the substance and beauty of your watercolor painting.

Techniques in applying paint are critical from the earliest stage of laying in the value statement (see part four) to the final stroke. While I do not start with a whole sheet of wet paper as many watercolorists do, I still use a variety of techniques in applying paint to control washes and edges.

In order to master these techniques, train your eyes to *see* hard and soft edges, flat and graded washes. You cannot paint what you do not see.

Sometimes my workshop students struggle to paint the shadows of draped fabric. I explain that if you look at each shadow, often one side of the shadow is a soft edge, and one side is a hard edge. The students do not always notice the difference between a soft and hard edge, nor see all the shadows. When I point to each edge, they see all the shadows and their hard and soft edges emerging. Only then can they paint them, and what a feeling of newfound power they have! It is as if a whole new world is opened.

FLORABUNDANCE
39" × 27" (99.1cm × 68.6cm)
Private collection.

Variety Adds Richness

All the subtleties and variations of edges and washes add to the richness of the profusion of flowers in this painting. Crisp edges give snap to the painting, as in the knife-edge of the vase, the slivers of sunlight in shadows to the left of the vase and the waterline in the vase. Soft edges sculpt contours and give depth and roundness to forms. The interplay between the hard and soft edges keeps your eye moving around the painting and gives a feeling of depth and texture.

There are both flat washes and graded washes throughout the flowers, the vase and background. Each petal of the large apricot dahlia has a graded wash that subtly blends from dark to light, emphasizing the contour of the petal. All these varying textures add to the glowing luminosity of the painting.

Sculpt Soft Edges—Wet Into Wet

Use wet-into-wet technique for soft folds of fabric, soft contours of flower petals or rounded fruit such as apples and grapes. To create a soft edge, paint clear water along the edge you want to be soft, and then apply the paint to the dry paper beside it. Use enough water to thoroughly cover the area of the soft edge, but not enough water to bead up on the paper. If the water beads up on the paper, the pigment cannot disperse itself into the paper. The more water you add, the lighter the color, whether water is added on the paper or mixed with the pigment.

For soft edges on both sides, apply clear water all over and paint the color in the middle. If you want a darker color in the center, apply clear water along both edges and paint the color on the dry paper.

Another way to get a soft edge is to paint the pigment onto the paper, and then use your brush with clear water to soften the edge. Go back and forth between a brush loaded with paint and another brush with clear water until you achieve the soft edge you desire.

Practice Painting Soft Edges

In the practice exercise below, use a mix of French Ultramarine and Permanent Alizarin Crimson on 300-lb. (640g/m²) rough watercolor paper. Each type and weight of paper absorbs paint differently, so if you change papers, experiment until you know how the pigment, water and paper work together.

Wet-Into-Wet Edges

To make these soft edges, mix French Ultramarine and Permanent Alizarin Crimson together. Paint clear water along the soft edges. Then brush the purple mixture into the shadow, touching the clear water. Use a darker color than you want because the water on the paper mixes with the pigment to lighten the color. Make the shadows subtle by coaxing a soft edge with a brush of clear water, or make the edge bold by letting the pigment ooze into the wet paper.

Add Layers

Glaze another shadow (see chapter six on glazing) with a soft edge over the first one when it is absolutely dry. If you glaze the second layer before the first is dry, the brush will disturb the first layer, resulting in a murky mess. Paint clear water where you want the soft edge, and then brush the pigment into the clear water to make a feathery edge. Brush each step with only one stroke, as additional strokes begin to lift the layer underneath.

Step A

Step B

Step C

Step D

(A) Water on Entire Area

Paint the entire area with water. Let it dry until the sheen is gone. Paint pigment over the water. If the pigment disperses too much, the paper needs to dry more; if the pigment leaves too sharp an edge, the paper is too dry. If the color is too pale, add less water to the pigment or the paper, or add more pigment to the mix.

(B) Water Alongside Area

Paint water up to the edge alongside the area where you want the soft edge. Paint pigment into the water. Do not muck it around and try to control or fix it. Leave it alone to work its magic! If the pigment disperses too much, let the water dry a bit more.

(C) Feathered Edge

Paint pigment up to the area of the soft edge. Paint water alongside the pigment and feather the edge smoothly with your brush of water. You can go back and forth between your brush filled with pigment and a brush with water until you get exactly the soft edge you want.

(D) Bloom

A *bloom* forms when you paint water onto pigment that is not completely dry. Blooms are accidents of watercolor painting, but we can use them to our advantage and even make them happen. Paint pigment on your paper and let it dry until it is no longer shiny. Then drop some water into the pigment and leave it alone.

Create Crisp, Hard Edges—Wet Into Dry

Use the wet-into-dry technique for hard edges, such as those in shadows, vases, leaves and tulip stems. Use the fullest part of your brush for broad curves and the tip of your paintbrush for line work. Vary the size of your brush with the area you are covering and the amount of details you are painting around.

Sometimes you want a crisper edge than you can achieve with your brush alone, like for the side of the vase or a tulip stem. Place drafting tape on the inside of the vase while painting the background. Pigment gathers at the edge of the tape, making a dramatic edge. When this is dry, apply the tape to the background while painting the vase.

Occasionally you want to save delicate white lines, or small dabs of white paper that are difficult to paint around. Apply liquid frisket with a brush or drawing pen to save these white areas.

Practice Painting Hard Edges

To make the most of hard edges, practice until you know what type and size brush gives you the best edge for what you are painting. Experiment with drafting tape and liquid frisket as well. For the exercise below, paint a mix of French Ultramarine and Permanent Alizarin Crimson on 300-lb. (640g/m²) rough watercolor paper; use old no. 0 and no. 5 sable brushes and a fine-point drawing pen to apply frisket.

Wet-Into-Dry Edges

To make hard edges, paint a mixture of French Ultramarine and Permanent Alizarin Crimson onto dry paper, carefully painting up to the crisp edge of the fold or flower. The large shadow area on the left has crisp edges in the upper left, as well as along the long fold that ends in the flower outline in the lower left.

Brush
Use your brush to make a crisp margin on two center vertical lines. Most hard edges can be painted with a carefully controlled brush.

Drafting Tape
Paint a hard edge using drafting tape to make a perfectly smooth margin on two vertical center edges. Even on rough paper, the center edges are smooth and straight. Use artist-quality drafting tape and leave it in place only as long as necessary. Do not use regular masking tape: It leaves a sticky residue on the surface of your paper.

Use as dry a brush as possible when applying reds along tape, as they tend to sneak beneath the surface of drafting tape.

Frisket
Paint hard edges using liquid frisket to mask off paper to save delicate lines or larger areas of white paper, on two vertical center edges and smaller white shapes. The uncontrollability of frisket prohibits perfectly straight, uniform edges, but it does allow you to save whites where painting around them would be difficult. I prefer untinted frisket; although it is more difficult to see where you put it, it does not stain the paper. Leave frisket on the shortest time possible for easiest removal.

Water Pushes Pigment to Outside for Crisp Edges

An exceptionally useful technique is to paint pigment on paper and immediately drop clear water into the center of it with a clean brush. Adding water this way pushes the pigment out of the center toward the outside. The center is pale, and a very crisp, dark edge forms around the perimeter, almost as if you painted an outline around the object.

Practice Pushing Pigment to Outside

For especially crisp edges or to wash out the center of an area, use clear water to push the pigment out of the center toward an edge. Practice on both large and small areas until you have control of this useful technique. In the exercise below, use a mix of French Ultramarine and Permanent Alizarin Crimson on 300-lb. (640g/m^2) rough watercolor paper.

Drop Water Into Pigment
Paint a circle of color. Then, with your brush, immediately drop clear water into the center, pushing the pigment to the outside. If the pigment does not move enough, add more water. Once you have a feel for pushing pigment in a small area, try it in a larger area.

Push Pigment to Outside
To make a luminous deep shadow, paint the long vertical area to the right of center with a mixture of French Ultramarine and Permanent Alizarin Crimson, and then wash the center of the area with a sable brush full of clear water. The water pushes the pigment to the outside of the area, allowing white paper to show more through the center and making a hard edge along the left side of the fold of the draped fabric. The shadow appears dark, but is luminous with white paper showing through the center. Feather the right side of the new shadow into the previously painted soft edge. The shadow in the corner of the blanket at the upper left also uses this technique of dropping water into the center to push the pigment to the outside, portraying the soft contours of the blanket.

COTTON SWABS ARE HANDY TOOLS

Use a cotton swab to soak up extra water or pigment that puddles when you get too much in an area. The swab does not disturb the paper and does not make the water or pigment run all over the paper as a paper towel might.

Water Pushes Pigment to Center for Soft Edges

Sometimes you want a soft edge with a graded wash, like in the individual petals of the large apricot dahlia in *Florabundance* (page 68). Concentrate pigment toward the middle of an area by pushing the pigment with clear water painted around the outside.

Push Pigment to Center

Using water as your painting partner, capture the roundness of objects, such as grapes, by painting pigment and using a brush full of clear water to nudge the pigment back toward the center. By dispersing the pigment, you leave a beautiful softness toward the outside, with the pigment concentrated in the middle. By painting just a little pigment, and then using water to push it softly back to the middle, the round translucence of the grapes emerges.

Practice Pushing Pigment to Center

Paint the pigment *first*, and then blend with clear water. You can achieve colors that are very dark blended to light, with the pigment concentrated in the center. Use a mix of French Ultramarine and Permanent Alizarin Crimson on 300-lb. (640g/m²) rough watercolor paper to achieve this effect on the exercise below.

TWO-FISTED PAINTING

One of my most important tools is a second brush loaded with clear water. It is ready to soften an edge, to make the color flow in a more painterly way, or to make a graded wash. I sometimes apply the clear water to the paper before I paint; at other times I apply the clear water to the paper after I have painted the pigment. Or I can make the pigment run to the middle by placing the water on the outside edge of an area, such as the soft fold of fabric.

Paint Water Around Pigment

Paint a circle of color, then paint around it with a brush full of water. The water softens the edge and pushes the pigment toward the center, making it darker. By painting the pigment directly on the paper, you can make the color as dark as you want. Then by painting water around it, you can blend it to a lighter color. When you have mastered a small area, increase the size.

Graded Washes Add Vibrancy

Graded washes blend smoothly from light to dark. To create a graded wash, gradually add water into the color to make it lighter. A perfect graded wash is hard to achieve, but practice will help you discover how much water to add to make a smooth transition from light to dark.

Graded washes can be more interesting and intriguing than flat areas of paint. This is where you can use your creative intuition and imagination. For instance, in *Florabundance* (page 68) the shadow cutting through the center of the pink hibiscus in the lower right is dark through the center and paler toward the right edge. This gives the effect of a dark shadow, but is more interesting than a flat area of paint. It has the further advantage of making the pinks more vibrant than they would be over a flat purple.

Practice Painting a Graded Wash

A graded wash is one of the special beauties of watercolor. It is worth taking the time to learn how to do it so you can use it effectively in your painting. Apply a mix of French Ultramarine and Permanent Alizarin Crimson to small squares of about 3″ (7.6cm) on 300-lb. (640g/m²) rough watercolor paper. I find a 3″ (7.6cm) hake brush useful for adding water, and a 1½″ (3.8cm) hake brush perfect for smoothly blending the wash. Paint these squares until you can get the wash perfectly smooth. Then double the size of the square and practice again. Continue increasing the size until you paint a graded wash on a full sheet of paper. Then you can use this technique with confidence in your painting.

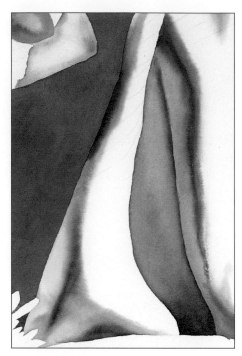

WATERCOLOR DRIES LIGHTER

Remember, watercolor dries several shades lighter than it appears when applied. The more water you paint on your paper or add to pigment, the lighter the color.

Smooth Graded Wash
To add another fold into the large dark shadow on the right and to make a more beautiful shadow, paint a graded wash, transitioning from light to dark. It takes a lot of practice to paint a smooth graded wash, but the results are worth the work! This new graded wash has a soft edge at the top and a hard edge downward from the midsection.

Disperse Color With Water
Paint a graded wash by first painting water over three-quarters of the area. Then, starting at the opposite side, paint the pigment gradually, diluting the color with water. For the smoothest transition, paint clear water again and then maybe another layer of pigment, working from the opposite side, until you have a smooth graded wash.

Smooth, Flat Washes Add Punch

A flat wash means that the paint is uniformly even in an area. To achieve a flat wash, mix enough pigment for the whole area and apply it, working rapidly to keep the effect as smooth as possible. It takes practice to make a perfect flat wash. Flat washes can be very beautiful. In *Kaleidoscope in Red, White and Blue* (dedication page 5), flat areas of red are very powerful. Some people think I do this with an airbrush, but I use my series 7 brushes.

It is easier to paint a large flat wash on 300-lb. (640g/m²) paper than on lighter weights. When you paint a large wash on 140-lb. (300g/m²) paper, the water saturates the paper very rapidly, causing it to buckle. Pigment concentrates in the indentations of the buckle and disperses over the high points, so the wash is not smooth.

Practice Painting a Smooth Wash

You need to understand how your paper reacts to the paint-filled brush and how much time you have to paint the wash. To make a beautiful liquid wash, try to get it right the first time. Each time you go over the wash you will muck it up.

It is helpful to tip the painting slightly when laying a wash. Start at the top and paint toward the bottom. Gravity is your partner, keeping the paint flowing downward so you do not get back runs. You can keep a flat wash going over a wide area by washing lots of paint into the leading edge and pushing it down the paper. Then leave it alone. For this exercise, apply a flat wash of Winsor Violet on 300-lb. (640g/m²) rough watercolor paper.

Uniform Flat Wash
A flat wash of Winsor Red punches up this painting. Mix plenty of pigment and water: You do not want to stop in the middle to mix more. Paint the wash as rapidly as possible, trying to paint each area with only one stroke so you do not disturb the underlying shadow layer.

Paint Smooth, Even Color
Start with a 4″ (10.2cm) square. When you can make a perfectly smooth wash, practice on a 12″ (30.5cm) square. Then make a flat wash covering a whole sheet of paper. Be sure to mix enough paint for each job *before* you start to paint the wash: It is almost impossible to mix the exact color again if you run out of paint. Furthermore, part of the wash is drying while you take time to mix more paint, so the resulting wash will be uneven. A flat wash should be seamless.

PAPER AFFECTS WASHES

Even the selection of the type of paper contributes to the beauty of washes. I purposely paint on rough-textured paper, even though I like minute details. I want the painterly quality the tooth of the paper gives to washes.

1. Learn to see the difference between hard and soft edges and flat and graded washes. You cannot paint what you cannot see.

2. Use the wet-into-wet techniques to paint soft folds and contours.

3. Create the hard edges of vases, stems, leaves and shadows with wet-into-dry techniques.

4. Use liquid frisket or drafting tape to produce a crisp, hard edge or to save the white paper.

5. Graded washes blend smoothly from dark to light as you add more water to a color.

6. A flat wash is a uniform, even color painted with smooth strokes and a soft brush.

7. Be sure to mix enough paint for each wash before you begin painting.

8. A variety of hard and soft edges and flat and graded washes adds beauty, substance, texture and vibrancy to your painting.

PAINT BEAUTIFUL WASHES

Take time to make every wash beautiful, no matter how small it is. Lay your wash down and leave it alone. Don't daub around in it and muck it up. Get it right the first time. A soft sable brush makes it easier to make beautiful juicy washes.

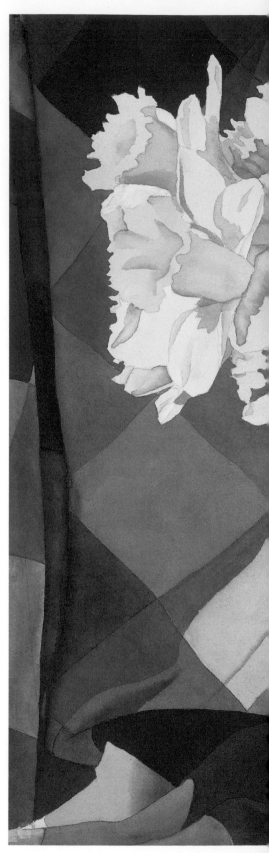

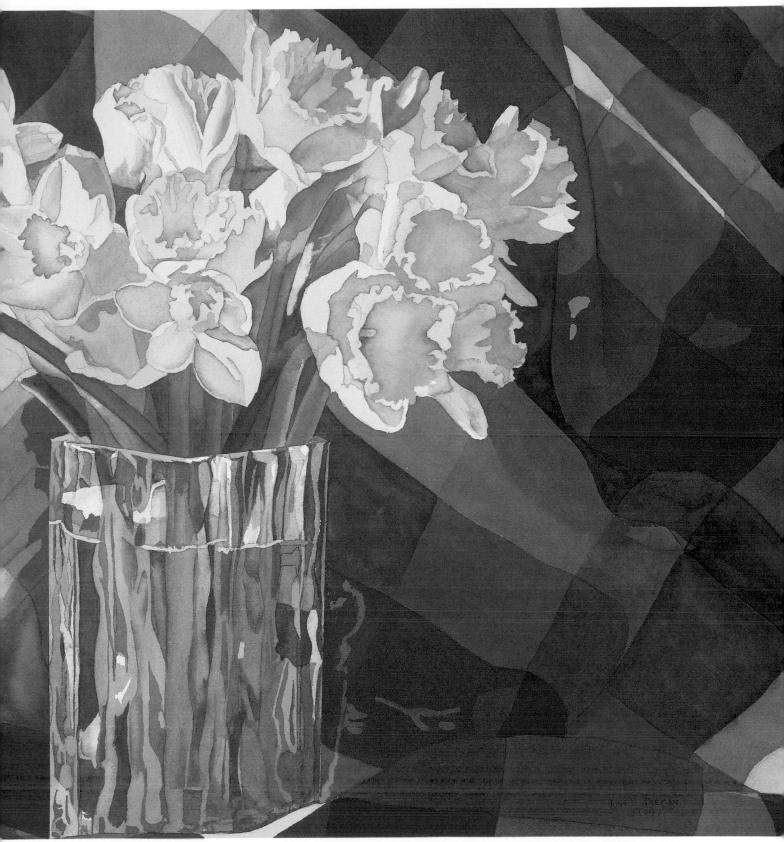

Washes and Edges Add Beauty

Wet-into-dry hard edges give the plaid fabric its crisp dramatic impact. These edges are contrasted with the wet-into-wet soft edges in the daffodil blossoms and shadows. The vase combines hard and soft edges and graded washes to capture the melding of glass, water and stems. Flat washes give vibrancy to each square of fabric to make the bold plaid convincing.

HERALDS TO SPRING
21½″ × 29″ (54.6cm × 73.7cm)
Collection of the artist.

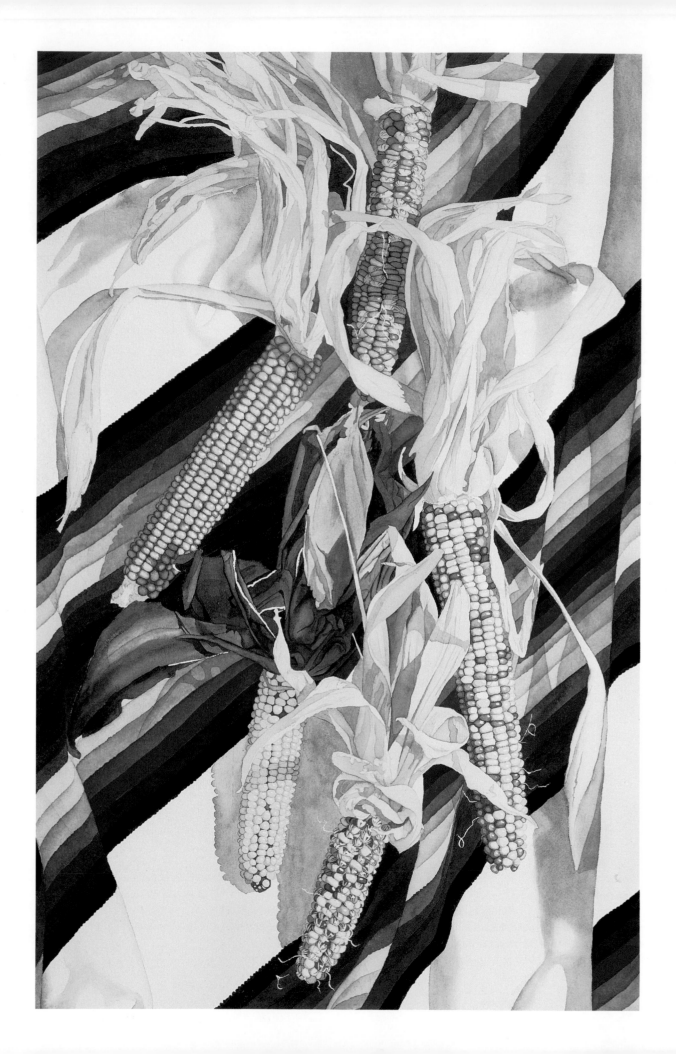

Build Glowing Color With Layers of Glazes

Painting a single color in a wash makes clear, beautiful color. However, a single wash of an individual color does not capture all the shadows, texture, depth or subtle nuances of color in our subjects. Luckily, watercolor provides us with glazing, a wonderful technique where a wash of one color is layered over a dried wash of another color. The layers of two separate colors achieve a greater richness or glow than one color alone or a washed mixture of the two colors.

One of glazing's primary uses is to create shadows by painting glazes under or over the local color. A painting's impact often comes from the interplay of light and shadow, and glazing is an effective way to emphasize the contrast between light and dark.

You can use glazing for other effects too. Some colors cannot be achieved in just one wash, but require layers of two or more washes in beautiful glazes. Use glazes to capture translucence of glass, water or fog. Glazes enable you to paint a darker subject, such as a bird or tree, over a lighter background, such as a sky or landscape. And you can produce interesting textures with glazes. For example, you can create the softness of peach fuzz by painting a wash of yellow and then glazing a reddish blush color over it. In all of these cases, layers of glazes are more effective than one wash alone.

Successive layers of glazes are at the heart of my watercolor technique. However, layering and mixing colors can also be a quick and easy path to muddy watercolor paintings. Learn how to use colors in glazing to keep your colors clear and brilliant.

SERAPE
33″ × 21½″ (83.8cm × 54.6cm)
Private collection.

Build a Painting With Glazes

Soft violet glazes provide shadows for the draped serape, as well as corn ears and husks. These shadows give form and substance to the design and provide a backbone for the bold stripes of the blanket. The rich colors of the blanket are built up with glazes applied from light to dark.

The red husk also profits from a series of glazes, starting with shadows, and layering washes of tan, a pale burgundy and then a reddish burgundy. Sculptural precision, created by layering up to six glazes each, characterizes each individual kernel of corn. The ears of corn hold their own against the background of the bold stripe.

Keys to Successful Glazing

A few simple guidelines help keep the colors of your glazes vibrant and enable you to take advantage of this useful and beautiful watercolor technique. If you have a problem with mud in your glazes, these prescriptions may help make your colors clearer.

Use Transparent Colors

Transparent colors glaze well over other transparent colors, at the same time keeping the brilliance and glow of the white paper. From the color chart you created on pages 37-39, you know opaque colors obscure the underlying layer, blocking the white paper from giving more power to the color. Transparent color over opaque color still retains satisfactory color, but loses some of the brilliance because of dulled white paper. Opaque color over transparent color is not effective, because the opaque color covers up most of the transparent pigment in the same way it dulls the white paper. Therefore, opaque colors are *not* the best choice when choosing a color to glaze. If an opaque color is the only way to achieve the color you want, paint it last. Glazing one opaque color over another is a quick way to muddy watercolors.

Paint Each Layer Only Once

Paint each layer only once over each glazed area. A second paint stroke into the wet paint begins to lift the color underneath, causing the colors to run together.

Let Each Layer Dry

You can glaze an area many times if you allow it to dry *completely* between glazes. In my Indian corn series of watercolors, I glazed each kernel up to six times, and the colors remained sharp and glowing. Painting into a partly dried area causes blooms, bleeding colors or uneven and murky washes.

Build From Light to Dark

Glazing light colors over dark ones is not effective. Light colors simply do not show up when glazed on top of dark ones. And each time you add water, even if just to glaze clear water over dried pigment, you dilute the pigment.

Glaze Warm Over Warm, Cool Over Cool

Keep vibrant, glowing color by glazing warm colors over warm and cool over cool. The farther apart the two glazed colors are on the color wheel, like mixing complementary colors, the grayer and muddier the result.

Paint With User-Friendly Paper and Brushes

Certain papers and brushes make it easier to create smooth, translucent glazes. A high-quality round sable brush is wonderful for glazing. The hairs are both soft enough and fine enough not to disturb the layer underneath, and yet they carry enough paint to cover a large area with one brush load.

Heavy (300-lb. [640g/m²]) paper is advantageous for glazing because it does not buckle. Buckling causes problems by creating depressions into which pigment sinks, resulting in uneven washes. The thinner the paper, the faster it succumbs to buckling. Furthermore, you can slosh a lot more paint around on heavy paper without it becoming too saturated, so each glazed layer dries faster. My preference is for rough or cold-pressed paper for glazing, not hot-pressed.

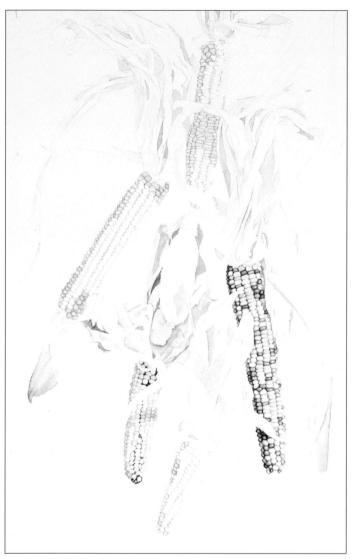

Preliminary Glazing

Build up the painting with transparent glazes, starting with a mixture of Rose Madder Genuine and French Ultramarine for shadows on the corn and husks. Paint a warm shadow on the red and yellow, or warm, ears and a cool shadow on the blue, or cool, ears.

After the shadows have dried, paint the local color with transparent pigment, building from light to dark. The yellow kernels are a mixture of Yellow Ochre, Aureolin and Rose Madder Genuine. Vary the mix slightly between kernels, because they are not all the same. The blue kernels are French Ultramarine grayed with Burnt Umber. The reddish kernels are Permanent Alizarin Crimson muted with a touch of French Ultramarine. Alternate kernels and rows.

Build Up Glazes

Continue to build up layers of transparent glazes, warm over warm and cool over cool, letting each layer dry between glazes. Once the corn and husks are finished, paint a purple glaze for the shadows on the serape. Then you are ready to build the stripes from light to dark. You can build up many layers of a rich, glowing color; your painting becomes more beautiful and convincing.

APPLY REDS LAST

Dried reds, such as Cadmium Red or Winsor Red, gush everywhere if you touch them with a wet brush. Use red as the final color to go on your painting. Also, paint reds with a single, smooth wash rather than building color up in layers.

Build Your Painting With Glazes

1 DRAWING AND FRISKET

Begin sketching with a no. 2 pencil and make your final drawing with a no. 6 hard pencil. Apply frisket to small areas of white you want to save, including highlights on each piece of fruit and the glass bowl, as well as embroidery stitches on the quilt. You can paint around bigger areas of white, such as the peeled part of the apple.

2 APPLY SHADOW GLAZES

Now apply the shadows with transparent glazes of various hues and intensities of purple, depending on the local color. Paint shadows using a mixture of French Ultramarine and Permanent Rose. For the darkest shadows, use Permanent Alizarin Crimson with French Ultramarine. Use a warmer (redder) mixture for the shadows on the peaches and plums and a cooler (bluer) shadow on the apples and grapes. At this stage you can see all the contours and shapes taking form. Let this first glaze dry completely before going on to the next layer.

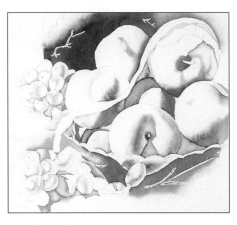

MATERIALS LIST

Paints
- Winsor Lemon
- Winsor Yellow
- Aureolin
- Scarlet Lake
- Winsor Red
- Permanent Alizarin Crimson
- Permanent Rose
- Rose Madder Genuine
- French Ultramarine
- Viridian
- Hooker's Green

Brushes
- nos. 3, 5, 7 round sable

Paper
- 300-lb. (640g/m²) rough watercolor paper

Other
- Frisket
- nos. 2 (soft) and 6 (hard) pencils
- very gentle eraser

3 YELLOW PEACH GLAZES

Paint a transparent yellow glaze on the peaches over the reddish purple shadows using a mixture of Aureolin and a touch of Winsor Red or Permanent Rose. Paint the glaze in only one stroke so you do not lift the violet shadow underneath. Paint an intense version of the color in shadow areas, and add water to dilute the color near the highlights. Let dry.

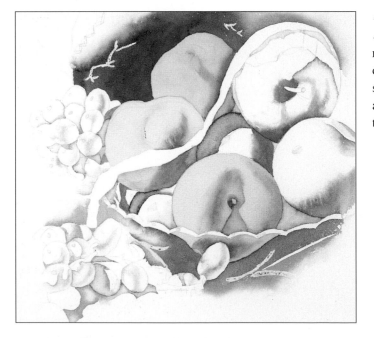

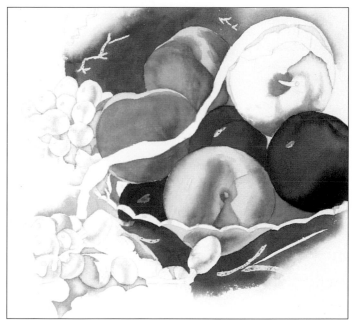

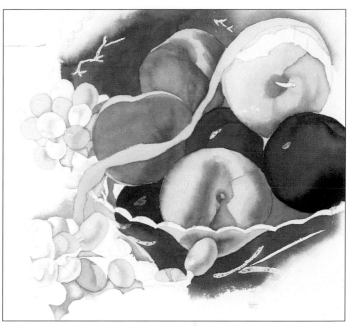

4 DEVELOP PEACHES AND PLUMS

Now glaze another transparent layer for the reddish blush of the peaches over the yellow glaze by adding more Winsor Red to the Aureolin glazing mixture. Paint the local color from light to dark, warm over warm. Finally, add a little Permanent Alizarin Crimson to create the darkest blush of the peaches. Paint a glaze over the plum shadows with a mixture of Permanent Alizarin Crimson and French Ultramarine.

5 GLAZE GRAPES AND APPLES

Working cool over cool, use a mix of Winsor Lemon, a touch of Hooker's Green and a whisper of Scarlet Lake to paint the grapes and apple. Glaze over the cool, bluish purple shadows of the grapes one by one. Painting alternate grapes and allowing them to dry speeds up the process. Vary the colors of the grapes. Add a drop of water in the center of each grape to push the color pigment away from the highlights.

Paint the apple, washing the color away from the highlight. Be careful to keep subtle, gentle greens.

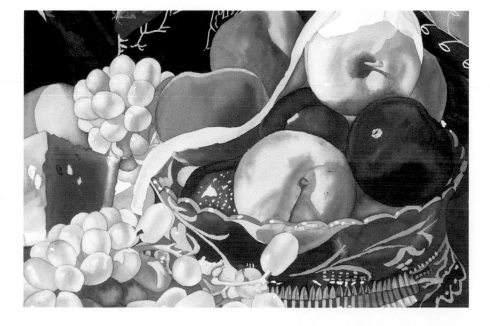

6 FINAL DETAILS

Transparent color allows each layer of glazing to shine. Building up layers adds to the richness and believability of the painting. Opaque colors do not work for this kind of building up of layers of colors. Frisket saves the etched pattern in the glass bowl, and a soft gray glaze of French Ultramarine dulled with a little Permanent Alizarin Crimson finishes the effect.

RICHES OF SUMMER
Detail

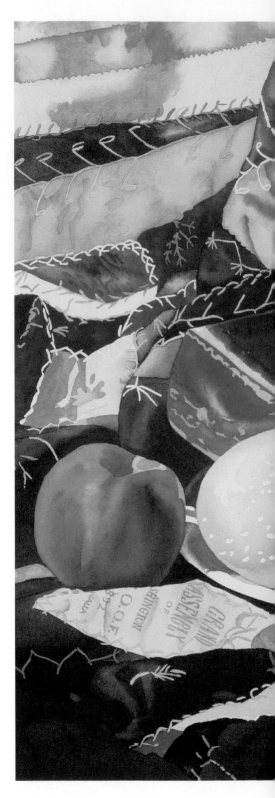

1. Building up layers of color with glazes is a way to create shadows (which give a strong design to the painting) and still retain beautiful colors.

2. Glazes are useful to produce translucence, interesting textures and luscious blended colors in your watercolors.

3. Use transparent colors to keep your colors unclouded and to take advantage of the power of white paper.

4. Paint only one stroke over each layer of glazing, because a second stroke will lift the preceding layer.

5. You can glaze many times, but allow each layer to dry completely before painting the next layer.

6. Build your glazes from light to dark.

7. Glaze warm colors over warm and cool over cool.

8. Use a high-quality, soft round sable brush and 300-lb. (640g/m²) rough or cold-pressed paper to increase your likelihood of success with glazes.

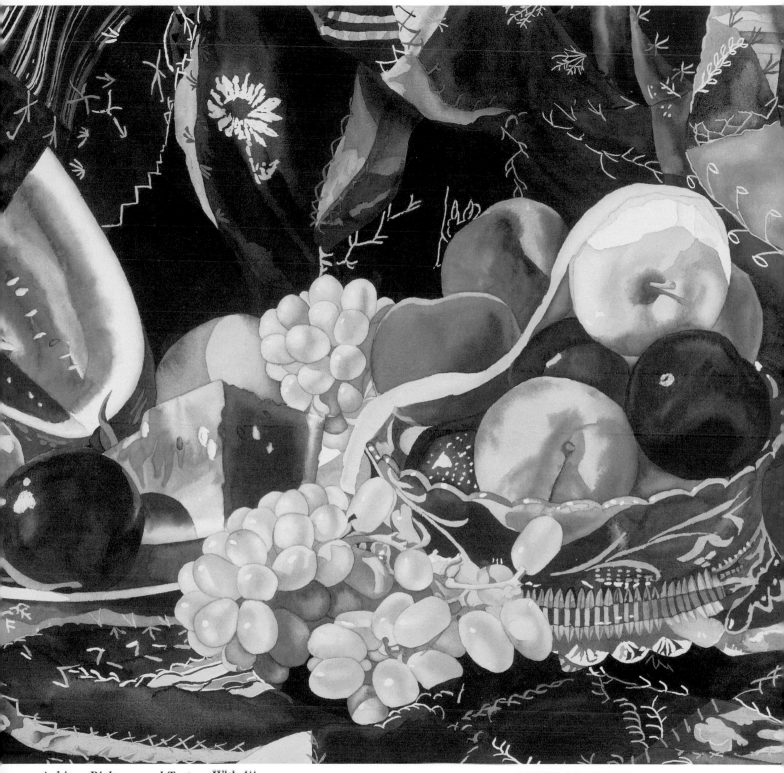

Achieve Richness and Texture With Glazes

White paper shining through the many layers of glazes helps give a power boost to the glowing colors of *Riches of Summer*. The colors of the fruit simply cannot be achieved with one layer. Shadows give the apples, grapes and peaches convincing realism. Purple plums relate the foreground to the background. The cut watermelon makes viewers drool! Glazing helps to achieve the rich colors and textural qualities of the fruit, from the shiny plumpness of each grape to the delicate softness of peach fuzz.

RICHES OF SUMMER
27½" × 39" (69.9cm × 99.1cm)
Collection of the artist.

Values Provide Structure

LA VIE EN ROSE
39″ × 59″ (99.1cm × 149.9cm)
Private collection.

Build a Foundation of Lights and Darks

Brilliant colors alone are not enough to make a successful painting. It is critical to provide an underlying framework for the brilliant colors in your watercolors, just as our skeletons give form to our bodies. You must plan your painting carefully so that you do not lose the impact of all the beautiful color in a confused value statement. When you paint with soft, neutral colors, values are more readily apparent. However, when you paint with vivid colors, it is easy to confuse colors with values. The *value statement* is the arrangement of lights and darks and provides the basic design, or backbone, of your painting.

Values define parts of a painting with respect to lightness and darkness. Values give composition and design as well as a feeling of dimension and depth. Furthermore, values give a painting luminosity and brilliance. Values are especially useful in making shadows, folds and contours convincing. You determine values either by choosing light and dark *local colors* or by placement of *sunlight and shadows*. A good painting combines the use of both.

Sunlight and Shadows

Sunlight and shadows create an arrangement of lights and darks without regard to local color. They give impact and drama to a piece of art, as well as defining the shapes of subjects and the design of the artwork.

For example, in *Grandmother's Treasures* (opposite) sunlight and shadows provide structure. The amaryllis blossoms are actually bright red, but they are painted every value from white, where sunlight strikes them, to a very dark burgundy, in shadow.

Sunlight and shadows are clearly visible throughout the crazy quilt patterns and colors in *La Vie En Rose* (pages 86-87). Make your shadow values a strong enough foundation to support all the brilliant colors you want to paint.

GRANDMOTHER'S TREASURES
38½″ × 27½″ (97.8cm × 69.9cm)
Private collection.

Strong Value Statement
My grandmother bought this tapestry for me to paint. I could not conceive any flower that could hold its own with the bold, busy design. But when I saw several red amaryllis blossoms at once, I knew I had found the perfect subject.

Squint your eyes and look at the painting. See how the amaryllis blossoms pop out from the busy background. This painting shows it is possible to use a medium value for the subject against a busy background of light and dark values. The key is that you use a *different* background value than the subject value.

Learn to See Values and Color Temperature

Paint With India and Sepia Ink

I trained myself to see values and color temperature by using both India ink and sepia (brown) ink. I spent about two years creating artworks resembling sepia-toned black-and-white photos. By using black and sepia, and mixing the two together, your palette can have three colors—a cool gray, a warm brown and a black/brown mixture. There is an infinite range of values with these three tones. The advantages of using these inks are learning to see color temperatures and values, as well as how to apply paint, without the confusion of color. Furthermore, as these inks do not lift when glazes are applied, I developed the highly refined glazing technique at the heart of my painting today. I still recommend this as the best way to learn watercolor.

As you gain confidence with the India ink and sepia ink, gradually introduce colors, beginning with one warm and one cool. Start with low-key (less intense) colors such as Burnt Umber and French Ultramarine. The purpose is to train your eye to not only be sensitive to values, but also to warm and cool colors. If you choose higher key (more intense) warm and cool colors such as Winsor Red and Winsor Blue, your painting will be more garish. This will be less helpful in training your eye to see values.

SEE DIFFERENCES IN VALUE

Squint your eyes to make sure you have a difference in *value* between subject and background, not only in color. Use the *value scale* (page 99) to gauge the value difference between subject and background.

Squint to See Lights and Darks

Squinting is also a way to train your eye to see values. It is an especially valuable tool as you try to sort out complex compositions and to determine values while looking at brilliant colors. When you squint, you block out the details and colors and see the values—the patterns of lights and darks.

Study Black-and-White Photos

You can also train your eye to recognize and understand values by looking at black-and-white photos. They do all the work for you—eliminating colors so you see value relationships clearly.

DETERMINATION
India Ink and Sepia Ink
12″ × 18″
(30.5cm × 45.7cm)
Collection of the artist.

Value and Temperature
Working on tan-colored paper, I used sepia colors for warm areas where the sun shines, like the highlights on the right side of the horse. Gray tones, from diluted India ink, define the cooler shadow areas, like on the white face of the calf. Dark values create simple, dramatic shadows.

Use Values to Emphasize Your Subject Matter

To paint brilliant colors in watercolors, it is imperative to plan the painting ahead of time so that it will have structure and design as well as color. You cannot just start splashing glorious colors and hope for the best!

Before you paint, think about how you can use values to emphasize your subject matter and make it stand out against its background. You must arbitrarily make the subject a different value than the background so the subject is clear to the viewer. Place light subjects in front of dark backgrounds or dark in front of light.

Consider the placement of colors in terms of values. You may have to change the color or shadow of either subject or background from what you see. Further-more, it is not enough for the subject to be a different color from the background: It must be a different value as well. Check that, when you squint your eyes, the subject and background do not meld together because they are the same value.

An artist once showed me a painting where the head of her subject appeared against a background of about the same value. If I squinted my eyes, I could not see the subject's head in the painting, although the body stood out plainly. If the artist had checked the values, she could have corrected this in the planning stage by making the subject and the background different values or by rearranging the background so a different value was behind the subject. A problem such as this is impossible to correct if you do not check the values until the painting is completed.

The following three images show three different ways to use values to make the subject stand out from the background. You can make the subject darker in value against a lighter background, or make the subject lighter against a darker background. You can even make the subject a middle value against a light and dark background. The important thing is that the subject matter must be *different* in value than the background. Without the darks and lights playing off each other, a painting is meaningless, like trying to see a white rabbit in a snowstorm.

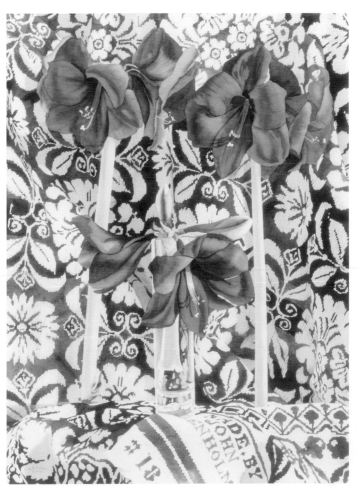

PLAN YOUR PAINTING

Take time *before* painting to make sure you find the most pleasing arrangement of objects, values and colors. Remember, you have control over what you paint. If you are going to spend your creative energies, make sure you spend them well. Also, plan how you will save those important whites.

Middle-Value Subject

The amaryllis show up clearly in the black-and-white photo. Although the values range from white to black throughout the painting, the amaryllis blossoms are clearly *different* in value than the background.

In the black-and-white photo you see the values of the painting, without regard to local color. The medium value of the amaryllis blossoms separates them from the busy black-and-white background pattern. Likewise, the broad, straight stems show well because they are also a different value than the background. This is a complex design and composition, yet it works.

Study the color photograph of this painting on page 88. When you add differences in color, the subject stands out even more dramatically.

Dark Subject, Light Background

A black-and-white photo shows the values in the painting clearly, without colors confusing your eye. The dark, solid shapes of the tulips stand out against the lighter, busy pattern of the quilt. The painting's value statement must be effective for the painting to be successful. Artists often use a different color to make a subject stand out from the background. More importantly, the subject must be a *different value* than the background as well! Not only do the red tulips show up clearly, but the vase shows up against the background because the edges are a different value.

Squint your eyes and look at the painting. The darker red tulip blossoms stand out strongly against the lighter quilt. This difference in values makes the painting dynamic. Color adds to the vibrancy, but the value of the subject must stand out from the value of the background.

Add details and colors freely, within the structure of the carefully planned value statement. In this case I included areas of red, yellow and green in the quilt to complement the rich red of the tulips and make your eyes dance between the foreground and the background.

RIBBON QUILT WITH TULIPS
20″ × 28″ (50.8cm × 71.1cm)
Private collection.

Observe how well the tulips show up in the black-and-white photo, although the local colors of the red tulips and the red in the blanket are the same. Use sunlight and shadows to make different values, since both tulips and blanket are red. I carefully position light values of sunlit tulips against dark values of shadowed blanket, or more importantly, place the subject against a *different*-valued background.

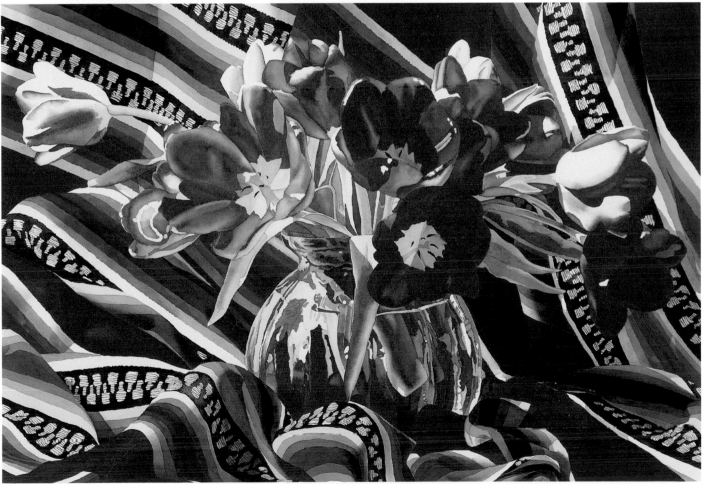

How can you see red tulips against a red background? Carefully arrange each of the red tulip petals against different values and colors; otherwise they meld together. Notice how the white highlights of the tulips make them stand out against the red background. Likewise, red petals appear against darker (or lighter) backgrounds. Examine each blossom and see how it shows up against the background.

Jubilation is a knockout in value alone, but when you add color, it is sensational. The red tulips play off the greens, blues, blacks and whites.

JUBILATION
27½″ × 39″ (69.9cm × 99.1cm)
Private collection.

Cure Commonness With Lights and Darks

Set off your brilliant colors to their best advantage by using predominantly light or dark values in your painting. Using mostly middle values does not give the structure required to enhance vivid colors.

The local colors you choose for your subject matter will help determine the values of the painting. You can make a very dark color light by adding a lot of water. Colors such as Permanent Alizarin Crimson, Winsor Violet, Winsor Blue or black can span a large range of values from light to dark. Other colors, such as yellows, have only light values.

Before you paint, decide if you want predominantly dark or light values in your painting. Think about which will most dramatically display the subject and/or

Predominantly Dark Values

Without the benefit or confusion of color, study the values of the painting in this black-and-white photo. The painting is predominantly dark values. Light values of the tulips and vases show up more sharply against the dark background, whereas a light background would not be as effective. The sunshine sparkles more for being placed against the shadows.

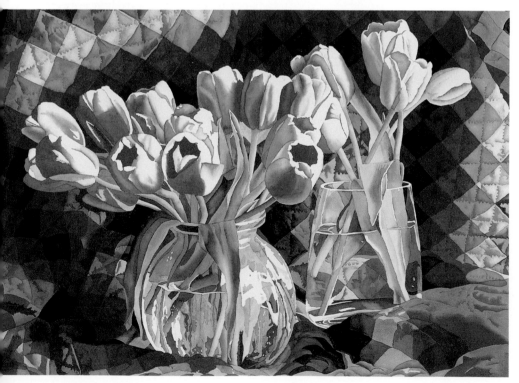

SUNSHINE AND SHADOWS
28″ × 39½″ (71.1cm × 100.3cm)
Collection of the artist.

The interweaving of sunlight and shadows gives the painting its name, as does the Amish quilt pattern. The overall dark values in this painting dramatically contrast the light pink tulips. You best appreciate the brilliance of sunshine when it is contrasted against shadows. The pink tulips range in value from white through pale pink to very dark pink. Their colors echo the quilt pattern, in which each color has three increasingly darker shades as it goes from *sunshine* to *shadows*. Squint your eyes to see the tulips leap out from the quilt. Each light blossom stands out against a darker background. Each petal stands on its own against its neighbor.

feeling you wish to portray. A half-and-half split between dark and light values is not usually as interesting as mostly dark or light. Generally, a one-third to two-thirds proportion between dark and light is more pleasing and exciting.

The paintings on these two pages show different ways to paint the same pink tulips. Both paintings are strong and successful. *Sunshine and Shadows* (opposite) has predominantly dark values, giving a more dramatic impact to the highlights. The darker background emphasizes the pale, rounded shapes of both vases and tulips. On the other hand, light values are predominant in *Dresden Plate Quilt With*

Tulips (below). The light-colored quilt accents the darker pink globular tulips. A dark value in the vase would split the painting in half between light and dark values and diagonally from lower left to upper right.

Predominantly Light Values

In the black-and-white photo we look only at the value structure, without the interplay of pinks and blues. Note the overall light values of the painting, but also note how critically important the dark shadows are in giving shape and form to flowers, the vase and the quilt. Without these dark areas, the painting would be ordinary and wishy-washy.

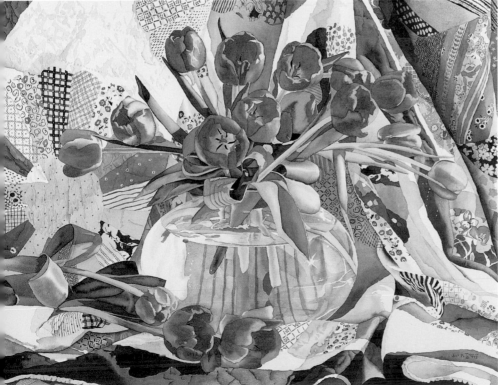

DRESDEN PLATE QUILT WITH TULIPS
28″ × 39″ (71.1cm × 99.1cm)
Private collection.

Squint your eyes and notice how this painting is predominantly light values with some darker accents. See how successfully the pink, round tulips show against the light background. Placing the light, round vase against darker shadows emphasizes its shape. The darker blue quilt pieces keep your eye moving around the painting. While most of the painting is light to middle values, there are some very dark areas that give power to the painting.

Use a Full Range of Values for Dynamic Paintings

Brilliant colors call for strong designs, and this means using a full range of values, from light to dark. Before you paint, think about how you can use a large range of values to energize your design. Be careful not to lose some of your power by choosing too narrow a range.

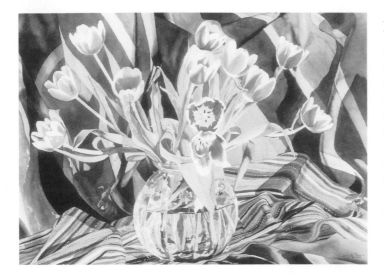

Full Range of Values

This painting has a very dramatic impact and a full range of values from white to black. This black-and-white photo helps us see the values without regard to local color. Notice the full range of values throughout the painting and how dramatically the tulips stand out against the lively background. Tulip petals show a large range of values from white to dark, and the striped fabrics range in value from white to black as well.

Strong shadows force their way through the different stripe colors, and dabs of light cavort around the painting. Values determine not only the shadows, but also the contours of the tulips, the folds of the fabric and the very shape of each object. The stripes are different colors and values as well.

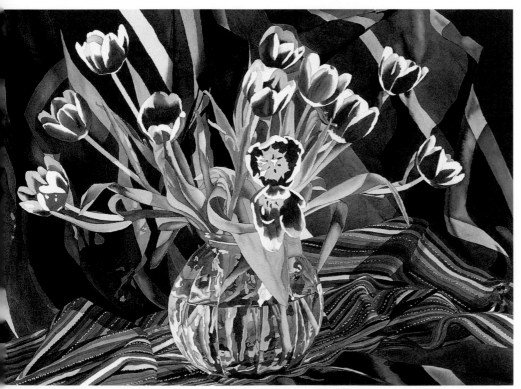

FANTASIA
29″×40″ (73.7cm×101.6cm)
Private collection.

The bold, colorful stripes in the two fabrics could easily overpower *Fantasia*, but the extreme strength of the underlying framework of shadows makes the painting successful. Shadows stand out, even with the bold striped fabric. The individual stripes include a full range of values as well as different colors. The interplay of all the different values and colors makes *Fantasia* a very lively, dynamic painting.

Squint your eyes. See how the white edges of the tulips pop out, echoed by the white edges of the vase and the white stripe running through both fabrics. A full range of colors and values animates the painting.

Exaggerate Lights and Darks for More Drama

When painting with brilliant color, take care to exaggerate lights and darks in the underlying shadows and highlights. Vivid washes of local color overwhelm delicately hued shadows. Make your colors more vibrant and your values darker or lighter than you think they should be.

Remember: One of the keys to beautiful watercolors is to let the white paper glow through the color! Even though you want to exaggerate your values, let the white paper show through the darkest colors to keep them vibrant.

In judging an art contest, a local group asked me to make comments to each artist about the paintings. I found the paintings generally needed a stronger value statement. Either artists were afraid to make strong values by using both very dark and very light, or the values did not come across with the strength the artist wanted. The paintings tended toward the middle range of values.

It is safe to paint middle-of-the-road paintings that do not require you to commit yourself to strong values. If you have middle-of-the-road confidence, your paintings will reflect it. To make paintings that are strong statements, be bold in your values. There is a risk in making bold paintings, but once in a while you will create a masterpiece.

SIMPLE JOYS—AMISH SAMPLER
27½″ × 39″ (69.9cm × 99.1cm)
Collection of the artist.

The interplay of lights and darks makes the rich colors come to life. Sunlight dancing over the simple tulips and sumptuous, dark colors of the Amish quilt portrays a joyful mood. The highlights represent sparks of joy in austere surroundings.

Squint your eyes and see how the white splotches of sunlight pop out in dramatic contrast to the rich, dark shadows.

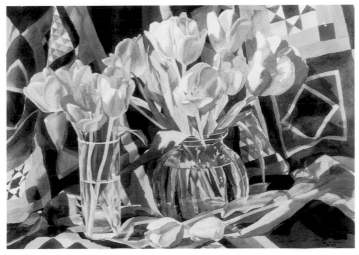

Exaggerate Values
I exaggerate the values in the tulips, from white to very dark. Perhaps the juxtaposition of the light tulips against the darker patterns of the quilt makes it even more dynamic.

The shadows of the folds are strong enough to hold their own with the pattern of the quilt. Although the vases are the same colors as the background, delineate the vase shapes by exaggerating different values on the edges.

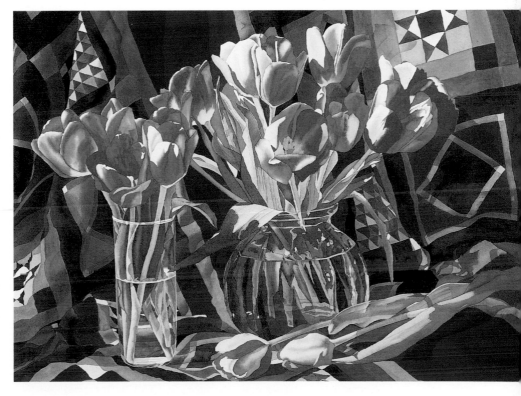

Play Shadows for All They Are Worth

Cast Shadows

Normally, light cast by the sun, or another light source, defines the highlights and shadows in a painting. There can be a single light source or several light sources. Starkly dramatic paintings can result from a strong single light source, which is why photographers often prefer early morning or late evening as a source of light.

When you paint with brilliant watercolors, think about making shadows strong enough to show up through the intense hues. Figure out your main light source. Is it strong or weak? You do not want a strong cast shadow in a pale painting of fog, but neither do you want weak cast shadows on a sunny day. Strong sunlight makes strong value statements, with great contrast between lights and shadows. These strong shadows will enhance your brilliant watercolors.

Reflected Light

See if you have a secondary light source and/or reflections and determine how they come into play. Sometimes light or color bounces off a light object in a painting onto another subject, or dark bounces off dark. Reflected light is complex, but it can lead to some wonderful effects. Take advantage of these beautiful reflections of light and color any time you can, and exaggerate them for more impact.

Control Your Shadows

Play around with the shadows until you get the most beautiful shapes. This is the fun part, where you can rearrange to get the effect you want. The reflections and shadows of sun shining through vases help make my paintings effective. The shadows are not accidental. I control where they fall for beautiful, eye-catching shapes.

The two still-life arrangements pictured below show the difference you can make by playing shadows for all they are worth. The still-life setup on the left takes the light, drape and shadows as they come. The still life on the right, however, shows how manipulating beautiful shadows and shapes creates a pleasing arrangement. This second setup has strong values and colors and a sense of movement and a feeling of depth. The arrangement will make a dynamic and brilliant watercolor painting.

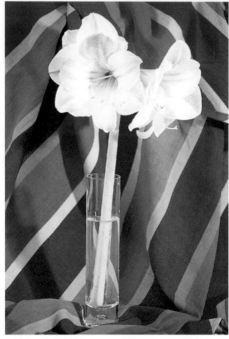

Weak Still Life

At first glance this setup appears to have the ingredients for a successful painting. The subject is a different value than the background. There is a range of values, from white to fairly dark. It has a pleasing flow of *brilliant* colors.

However, if you squint your eyes, the shadows are weak and simple in shape. The arrangement has only light to medium values and looks flat. Your eye trails down the fabric stripes and out the corners of the photo. The vase blends into the background. The flowers are almost all white and seem flat and unconnected to the background.

Strong Still Life

By rearranging the still life and adding a stronger light source, the composition becomes more exciting. Now there are values from white to very dark. The light falls in such a way to show the shapes and details of the amaryllis, as well as strong shadows on the background. The amaryllis has a full range of values that connects it to the background.

Squint your eyes. The amaryllis blossoms and stem are distinct from the background. The shadows give structure to the composition. Taking time to play around with shadows results in a more beautiful and improved still-life arrangement.

Value Scale Gives Full Range of Options

A *value scale* helps measure the full range of light and dark in planning your paintings. Painters often start out timidly, and the white paper fools them into thinking their values or colors are stronger than they are. Even a medium value seems very dark all alone on a large sheet of white paper. Using a value scale helps you measure how strong your values are so that your brilliant watercolors do not consume your shadows.

The fact that most watercolors dry lighter than the wet color makes it even harder to get the darker values. We mix a color that looks strong and dark. Yet when it dries on our paper, it loses some of its punch. As watercolorists, we must compensate for this by mixing more intense colors, knowing they will dry lighter.

Although watercolors are customarily painted from light to dark, I like to paint some medium-to-dark values early in the painting. It helps me judge the values as I paint. Taking a bold step with values from the beginning reduces the chance of ending up with an anemic painting.

Warm and Cool Value Scales

Black is not transparent and dulls other colors, so I do not use it to achieve dark values or shadows. I prefer to think of values as warm or cool colors and paint them accordingly. I translate the black-and-white value scale into two more useful value scales: warm and cool. For shadow colors, select transparent colors that allow the white paper to show through for more glowing colors. These colors should span the range from white to black. This eliminates yellows.

Transparent French Ultramarine mixes well with Permanent Alizarin Crimson and makes lovely warms and cools. Other blues with enough intensity tend to be too dominant and staining. No other reds have intensity and transparency enough to make a good mix. Experiment with values by mixing warm and cool purples with French Ultramarine and Permanent Alizarin Crimson. These colors are transparent, and their intensity spans the range from almost white to almost black.

Value Scale
Use this black-and-white value scale to judge the value of the colors you use in painting, as well as the gradations between the values. Be especially conscious of the middle value, and compare your values to it. If you want a light value, make sure your color is lighter than the middle value.

Squint your eyes and compare your mixed color with the value you think it will be. Knowing that most watercolors dry lighter, use the value scale to make sure your color's value is dark enough.

Make Two Useful Value Scales

Make your own warm and cool value scales. Keep in mind that watercolors fool the eye. They dry lighter and more anemic-looking than they appear when wet. Do not agonize over how cool or warm they appear or if your values are not right the first time. As with everything else, you will improve with practice.

MATERIALS LIST

Paints
- French Ultramarine
- Permanent Alizarin Crimson

Brushes
- medium-size Kolinsky sable round (5 to 9)

Paper
- 300-lb. (640g/m²) rough watercolor paper

Other
- Drafting tape
- No. 6 (hard) pencil
- Hair dryer

1 DRAW BOXES AND LAY WASHES

Draw two sets of nine 1½" (3.8cm) adjoining square boxes. Mask the edges of each row of boxes with drafting tape to make crisp edges. Mask the edge of the first box, which will remain white. Be sure to press the tape firmly so paint does not creep under the edge.

Using mixtures of French Ultramarine and Permanent Alizarin Crimson, wash a cool (tending toward French Ultramarine), pale mix of these colors over the eight remaining boxes of the top row. Then wash a warmer (tending toward Permanent Alizarin Crimson), pale mix of these colors over the eight remaining boxes of the bottom row.

2 LAY IN VALUES

Let washes dry thoroughly between steps so colors do not run together. You may want to use a hair dryer to speed the process. When they dry, mask the edge of the second box. Use the black-and-white value scale from page 99 as a guide to paint the remaining boxes.

Paint the next darker color over the remaining boxes, continuing a cool mix on the top row and a warm mix on the bottom. Let dry, mask and continue in this way until you have painted all the boxes in increasingly dark values, making equal gradations between each box, with the middle boxes a midtone. Make a uniform, smooth, flat wash in each box. The five lightest values have been painted here.

Use these two value scales to help plan and paint your watercolors. These value scales provide a basis against which you can judge all the colors and values you use in your painting. Accustom yourself to being aware of the white, middle and darkest values. This will help you judge the values in between and to gauge all your values in relation to these three. Squint your eyes to compare the colors and values. Always think about whether you want to use a warm or cool color in your painting.

COOL VALUE SCALE

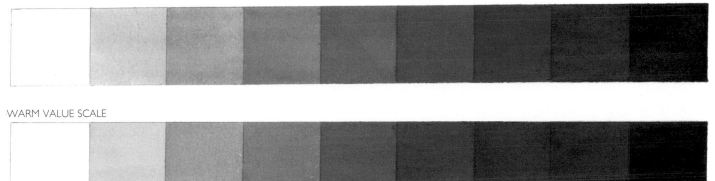

WARM VALUE SCALE

Use these two value scales to compare all your colors and values as you plan and paint.

1. Emphasize your subject matter by making the subject a different value than the background. Consider placement of colors in terms of values.

2. Decide if your painting will be predominantly dark or light—a half-and-half split is not as interesting as a 30 percent to 70 percent division.

3. Use a full range of values from light to dark for dynamic paintings.

4. Exaggerate lights and darks for dramatic paintings—make the lights lighter and the darks darker.

5. Play shadows for all they are worth. Figure out your main light source and if you have a secondary light source and/or reflections. Play around with shadows until you get the most beautiful shapes.

6. Use value scales to help determine the full range of lights and darks in your painting.

7. Each painting needs a solid pattern of lights and darks that details do not undermine or interrupt. By securing this pattern at the start, the painting reads as a unit when you finish.

CHECK YOUR VALUES AS YOU PAINT

To see how values and shapes develop, prop your painting across the room and look at it from a distance. Do this at regular intervals, from the earliest stage of the drawing to the completed painting.

In my workshops, when class members ask for help, I often put their paintings upright across the room. Almost immediately the students can see for themselves what is wrong and how to correct it. Every fifteen minutes is not too often to stand back and look at your painting. This is one way to see how the painting is taking shape and if your values show the strength you desire.

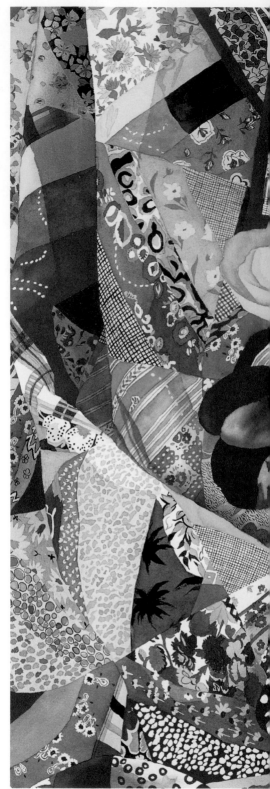

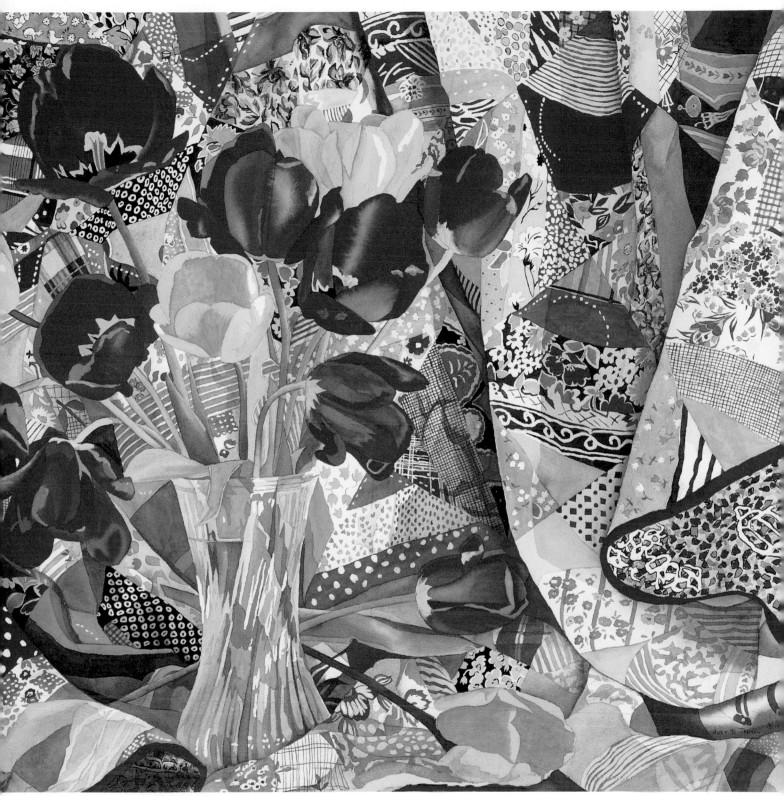

Value and Temperature Give Power

This is my most extreme example of detail and color, and yet the value structure remains strong. The painting is three-dimensional despite its complexity. Differences in value and temperature between background and subject help contribute to the power of this painting.

KALEIDOSCOPE II
27″ × 38½″ (68.6cm × 97.8cm)
Private collection.

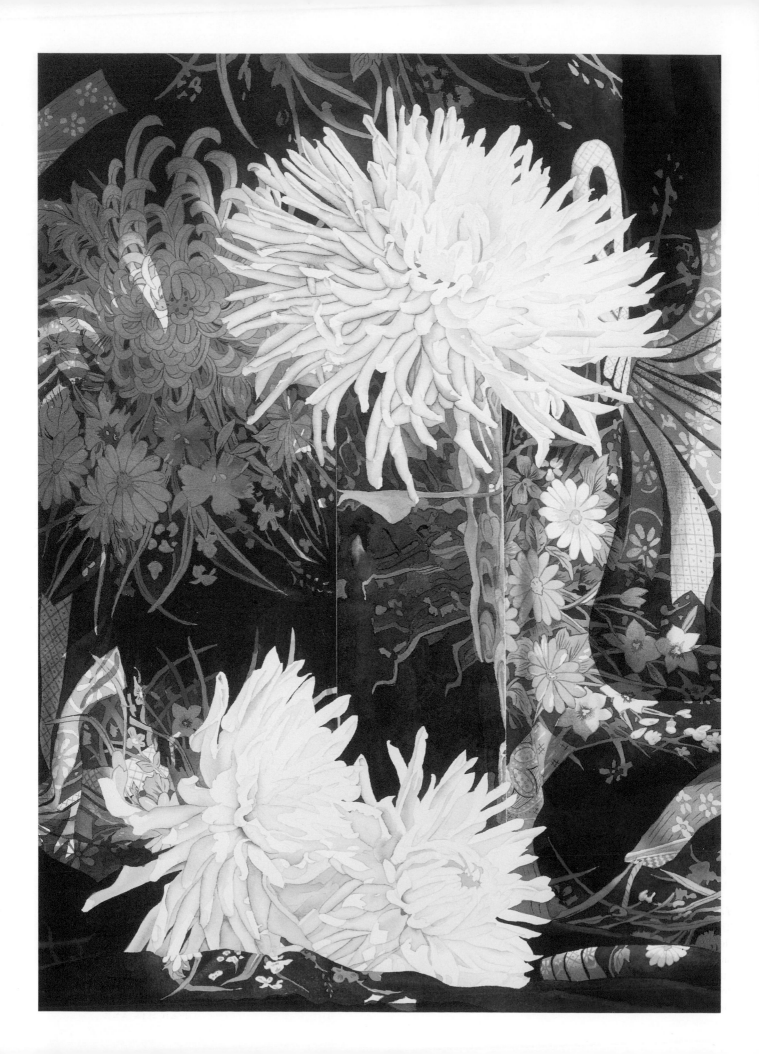

Discover the Magic of "Disappearing Purple"

Some friends visited my studio on two separate occasions. The first visit was during the beginning stage of one of my watercolors, and the entire painting was colored in purple. The second visit occurred upon completion of the painting. They were puzzled as to where the purple painting had gone.

A collector visited my studio and saw a painting in progress. When I explained that the purple flower she was seeing would soon be an apricot-colored dahlia, her eyebrows rose significantly, and she laughed as if I were joking! This is the magic of the disappearing purple. In the finished painting, with all its bold colors and intricate patterns, viewers are unaware of the underlying purple shadows. These purple shadows vanish into a neutral value statement. Yet my friends who witnessed the original purple painting still shake their heads and wonder where the purple went!

In painting conventional sketchy, loose watercolors, it is easy and customary to add the shadows as you build up the painting from light to dark. To paint watercolors with more color, size and detail, however, adding shadows as you go along becomes increasingly difficult. It would be impossible to paint *Happy Coat* (opposite) by adding the shadows as you go along. In the shadow to the right of the large white dahlia, the pattern in the fabric overlaps the soft edge of the deep curving shadow. Also, the pattern continues throughout the shadow to the left of the vase. You simply could not add these shadows after painting the fabric pattern without muddying the colors. Nor would these shadows have their dramatic effect if they were added later, even if it were possible. The resulting painting would not hold together.

HAPPY COAT
39″ × 28″ (99.1cm × 71.1cm)
Collection of the artist.

Three-Dimensional Quality

The trick with *Happy Coat* is to keep the white dahlias from being overpowered by the busy, flowered pattern or the vibrant Chinese-red silk. This multicolored painting has plentiful details and a three-dimensional quality. The simple white dahlia projects out from the background. The purple substructure shows careful attention to shapes and a full range of values—warms and cools, soft and hard edges. It helps push the intense red of the silk into the distance. All the elements contribute to the richness and vibrancy of the watercolor.

"Disappearing Purple" Gives Structure to Painting

To paint colorful, large, detailed watercolors, I have devised a technique for establishing the values and shapes of objects in the painting. It is similar to the Old Masters' use of sepia as an underpainting in oils. They painted the whole artwork in sepia (so it looked like a black-and-white photo) and then placed local colors on top. I do the same thing in watercolor, but I use purple instead of sepia. I call this the "Disappearing Purple" technique. I devised this method because it is impossible to paint all the shadows with so many colors and details. Adding shadows to all the details only makes the colors run together, creating a muddy effect—the bane of watercolorists.

As I begin each watercolor painting, I apply all the shadows in varying shades of purple. This underlying purple establishes the basic composition and value structure that forms the foundation for everything that follows. I can add colors and details later and still maintain a transparent glow showing from the white paper. Curiously, as the painting proceeds, the purple seems to vanish, disappearing into a neutral value statement. The final watercolor has the desired bright colors, depth, strong design, dynamic composition and convincing realism—and no conspicuous purple!

Why Purple?

In developing my disappearing purple technique, I first tried subtle, gray colors for shadows. However, the results were neither strong enough to hold the composition together nor did grays give me the jewel-like colors I love. The color chart you created on pages 37-39 gives you the information you need to choose a good color for shadows. To paint your shadows first, you want a color that gives the full range of values from black to white. However, you know that black tends to dull any color, and it would not make for brilliant watercolors.

Consider the primary colors (red, blue and yellow): We know they make the most transparent, vibrant colors when mixed with other colors. Yellows (including all the browns) prove useless, because they do not provide adequate dark values needed for shadows. Burnt Umber is not dark enough to make the really dark shadows and has the further disadvantage of making muddy colors because it is a mix of all the primary colors. Winsor Purple is not dark enough. Red or blue alone appears too garish to use as a shadow color.

A purple mixture from transparent blues and reds emerges as the key to the puzzle. A mixture of French Ultramarine and Permanent Alizarin Crimson is transparent enough that the white paper shows through, yet dark enough to make good dark values for shadows. This purple tends toward red or blue, depending on need.

There are benefits of this disappearing purple technique for watercolor painting. The underlying purple establishes the basic composition and value structure that forms the foundation for everything that follows, making the painting work as a unified whole. Once the purple shadows are painted, I can easily add the colors and details.

Strong Underlying Values Give Structure

To keep this sumptuous display of blossoms from becoming lost amidst all the intricacies of the silk pattern or the staggering red, this painting needs a very strong underlying value structure, as shown in this purple stage of *Happy Coat*. Purple shadows give structure to the painting. Without the structure of the value system, the colors would be meaningless, muddled and busy. The overwhelming purple of the painting at this stage disappears into neutral shadows of the finished painting. Furthermore, this dark shadow provides a dramatic background to pop the white dahlias into the center of focus.

The purple shadows vary from bluish to reddish and from flat to graded washes with both hard and soft edges. I paint around large areas of white, such as the large dahlia, so I can get the exact edges and shapes I want. Frisket saves the small dabs of light in the shadow.

Purple Underpainting Establishes Values and Shapes

In my kaleidoscopic paintings of bold, bright colors and complicated designs, I can neither paint each shadow as I go along nor add the shadows after most of the painting is complete. The colors would run together and create a muddy effect. Yet it is critical that I have strong shadows to give depth to the painting and to ensure the basic design does not lose itself in the busyness of the patterns. Shadows and highlights, after all, give a dynamic quality to the painting—breathing life into an otherwise static composition.

As I begin each painting, I apply all the shadows in varying shades of purple pigment. Purple makes an underwash strong enough to hold the basic design, yet transparent enough to allow the local colors to show through.

In the first layer of purples, I establish the design of light and shadows in the painting. I use both soft and hard edges to create contours of the flowers and folds of the quilt, and crisp the edges of vases or flower forms. I greatly exaggerate colors and intensities at this stage, so the underlying washes retain their power when the local hues and details are added. This is the point at which the design, shadows, shapes of flowers and folds of fabric all become convincing.

It is important at this stage to take the time to carefully paint soft edges, hard edges and graded washes showing the subtle nuances of different values in the shadows. The beauty of your purple shadows will shine through later color layers. The painting will look much like a black-and-white photo at this stage, but it will be purple and white. You will see shadows, shapes and values, but not color and details.

Start With Purple Wash
To begin each painting, I apply a strong purple wash, a mixture of French Ultramarine and Permanent Alizarin Crimson, to the shadow areas, as shown in this detail of the beginning stage of *Full Spectrum*. Previous experience has taught me these shadows need to be very strong to withstand the addition of brilliant color. At the beginning I paint a medium value that will be my value gauge.

Purple Gives a Full Range of Values

Remarkably, the purple underwash disappears whether I use a high-key (intense) or low-key (less intense) palette. The secret is in the selection of the intensity of the purple. In a few places where the strongest underwash is necessary, I use a mixture of very staining colors: Winsor Blue and Permanent Alizarin Crimson. Reserve this mixture for the darkest values, usually about 1–10 percent of the painting. This mixture results in a color that is almost black, but much more vibrant than black would be.

A mixture of French Ultramarine and Permanent Alizarin Crimson creates most dark values. This mixture is the workhorse of my technique, creating intermediate values as well. There is a great range within any of these mixes, depending upon the amount of water added. These washes will stand up under glazes of the boldest colors. For example, in *Happy Coat*, Scarlet Lake glazed over the background still allows the shadows to show dramatically—and the white paper still glows through it all.

In areas where the colors are more delicate, I use nonstaining French Ultramarine and Permanent Rose mixes, determining the needed intensity of the purple.

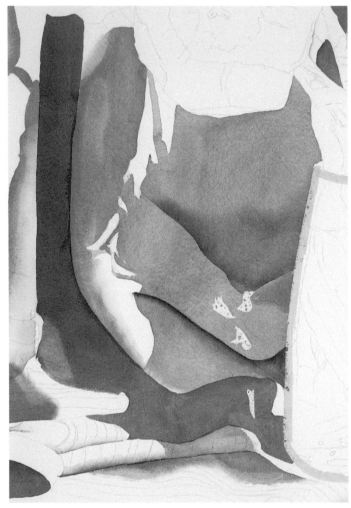

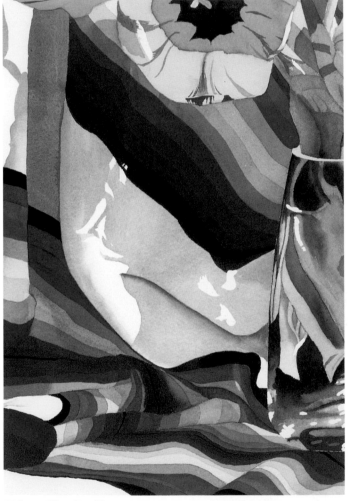

Full Range of Values

In this detail of the purple stage of *Full Spectrum*, the purple shadows establish a full range of values, from the palest hint of color on the drapery to the almost-black creases of shadow. Capture the lightest value with a mix of Permanent Rose and French Ultramarine. Use a mix of French Ultramarine and Permanent Alizarin Crimson to produce the darkest values. Create a full range of values from dark to light by adding more water to these two mixtures. Painting a full range of values between these two extremes helps give substance and believability to the draperies.

Values Give Backbone

Without the full range of values from darkest to lightest, the purple underwash would not show up when you add all the vibrant local colors to this detail of *Full Spectrum*. The darkest crease of the fold holds its own, even adjacent to the black stripe. The pale purple shadows work as well. Midtone purple shadows in the white area of the drapery effectivly describe both shadows and draping folds. Purple gives a full range of values to use in creating a design backbone for your painting.

Purple Can Be Warm or Cool

I vary the temperature of the purple, depending on the local color. I can balance the purple toward blue or red, depending on the hue and color temperature (from warm to cool colors) that will glaze over the purple. Use more blue for cooler colors and more red for warmer colors. If you use cool colors together and warm colors together, you will have greater harmony in your paintings.

Your color chart and color wheel from part two can help you choose cool or warm colors, depending on your need. If you do not think about warm and cool colors, you will likely mix cools and warms haphazardly—and the result will be mud.

I also vary the temperature of the purple, depending on whether I want an area to recede or advance in space. Cool recedes and warm comes forward in the picture plane, adding depth to a painting.

The color temperature, cooler (bluer) or warmer (redder), varies greatly, depending on local color, reflected light, design and depth. Each area of the underpainting has a different hue of purple, from almost red to almost blue. Many shadows are a combination of warm and cool tones, especially reflected light—cool on one side and warm on the other. This makes for beautiful washes in watercolor. Take advantage of it every chance you get.

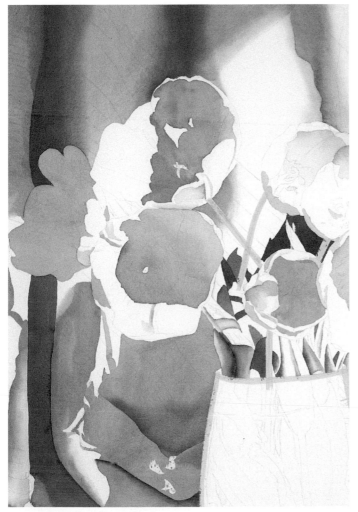

Warm and Cool Purples

In a detail from another part of *Full Spectrum*, I use a warm (reddish) purple for the shadows to pull the yellow tulips toward the viewer. A cooler purple (more blue) defines the draped folds, making them appear to recede into the background.

Many shadows are a combination of warm and cool tones, especially reflected light, which is cool on one side and warm on the other. The interplay of warm and cool gives a dynamic vibrancy to the painting.

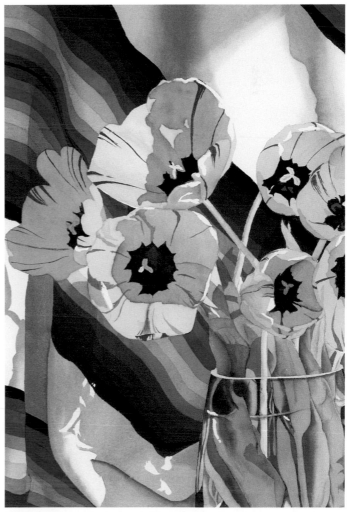

Warm and Cool Shadows Give Depth

In this finished detail of *Full Spectrum*, the bright yellow of the tulips over the warm shadows pulls them forward in the picture plane, while the relatively cooler hues and shadows in the serape make it recede into the background. The underlying shadows still show up under the brilliant local colors of both the serape and tulips. The shadow pattern gives structure to the painting.

Any Color Will Glaze Over Purple

You can create a purple which allows any color to be glazed on it without turning into mud. Remember, from our study of color, that the most brilliant colors come from pure colors or mixtures of two adjoining transparent colors. Once you have laid on your purple underwash and let it dry, add local color, matching color temperature for more vibrant results. The purple underwash enhances the jewel-like colors.

It is a good idea to practice on a separate piece of paper if you have some doubt about how a color will glaze over purple. Keep in mind the more colors mixed together, the more tendency toward muddy watercolors. For example, it is difficult to paint shadows in yellow objects without turning the color to mud. Yet, if you use a yellow hue for a shadow, you don't achieve a value dark enough. The secret is to use warmer purple shadows (almost red) for warmer hues of yellow, and to use cooler purple shadows (almost blue) for cooler yellow hues.

By having a strong foundation, you are free to apply pure, vibrant and exuberant colors. Make no mistake about it: Stroke each layer of glaze only once over the dry paper or it will lift the underlying paint, and all those carefully created washes will fade. If you want to glaze another layer, be sure the preceding layer is completely dry.

The two demonstrations that follow show how a painting progresses from its purple stage to a finished piece. They were done on 300-lb. (640g/m²) rough watercolor paper with Winsor & Newton artist-quality watercolors (which I prefer) and Winsor & Newton series 7 sable brushes. While following the steps, keep in mind that they are visual examples of my disappearing purple technique; they are not detailed instructions on how to create these particular paintings, although I have provided color names so you can see how colors interact and glaze over one another and try it for yourself.

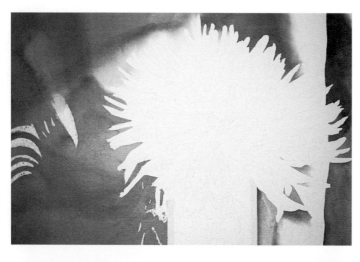

Strong Shadows Hold Their Own

A fairly dark purple creates the deep shadow behind the vase in this detail of *Happy Coat*. It takes a strong, dark shadow to hold its own with the intricate, multicolored flower pattern of the silk fabric that will be glazed on later. You might think at this point that the purple is too strong and too dark. Practice will teach you how dark the shadows must be painted. A mixture of the two transparent colors, French Ultramarine and Permanent Alizarin Crimson, retains the glow from the white paper.

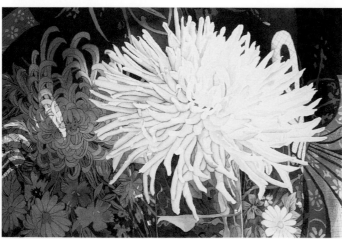

Glaze Any Color Over Purple

Colors from white, pink, lavender, green and blue shine within the purple shadow of the background fabric of *Happy Coat*. Any color can be glazed over purple. There are even touches of yellow, not to mention that vibrant red! The purple shadow, which may at first have seemed too garish and dark, recedes into a neutral value statement of strong shadow. Whether in the delicacy of the white dahlia or in the deep red folds, the purple underwash defines the basic design and three-dimensional appearance of the watercolor. The colors have a jewel-like clarity. There are no muddy colors here!

Tulips and Rainbows: Demonstration 1

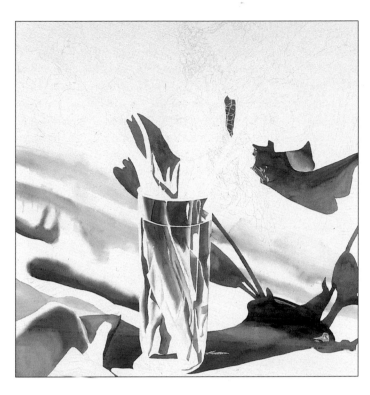

1 CREATE PURPLE UNDERPAINTING

Begin *Tulips and Rainbows* with a detailed pencil sketch, and apply frisket to save small areas of white paper, such as the fringe of the serape. For the darkest shadows, use a mixture of Winsor Blue and Permanent Alizarin Crimson. For intermediate shadows, use a mixture of French Ultramarine and Permanent Alizarin Crimson. Combine French Ultramarine and Permanent Rose to create the more subtle shadows.

The idea is to first establish the shadow values with flat washes, graded washes, soft edges and hard edges, watching the composition take place. I vary the shadow mixture from cooler (more blue) to warmer (more red), depending on depth, value, reflections and local color. I also use warmer colors in the foreground and cooler colors in the background to show depth.

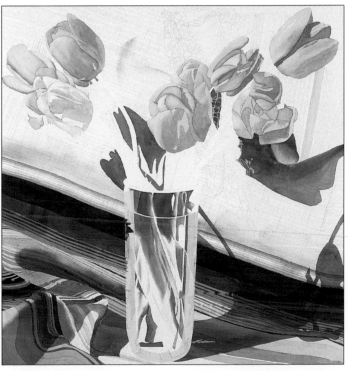

2 LAY FIRST COLORS

Use drafting tape to keep a sharp edge on the vase. Make small, frequent cuts along the edge of the tape to allow it to curve smoothly at the bottom of the vase. Leave the tape in place until the serape is painted.

Use a French Ultramarine and Permanent Rose mixture to create shadows on the tulips. Warm, redder colors in the shadows work well for yellow tulips. Paint on local color. Mix Aureolin and Winsor Yellow for the pale yellows. Use Winsor Yellow, Cadmium Yellow Pale or Cadmium Yellow for the more intense yellows.

Begin glazing the serape's stripes. Mix French Ultramarine and Burnt Umber for the pale blue stripe. Use Viridian with a touch of Permanent Rose for the green stripes, watering it down for the lighter green stripes. For the yellow stripes, first glaze a layer of Aureolin mixed with a touch of Hooker's Green. Follow this with a mix of Winsor Yellow and Scarlet Lake. Finish with a third layer of Scarlet Lake and Winsor Yellow mixed. Use Winsor Red for the red stripes, and glaze a mix of Permanent Alizarin Crimson and French Ultramarine over the red for the burgundy stripe.

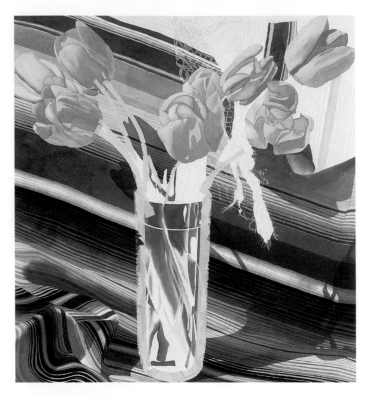

3 DEVELOP COLOR ON SERAPE

Use drafting tape to hold the edges of the stems when developing local color in the serape. Glazes of colors make the stripes, increasing in intensity from one color to the next. You must build up each darker color over the lighter colors. Paint the yellow stripe and continue to the next darker stripe as an underlay for the orange stripe. Then paint the orange over the yellow and as an underlay for the red, and so on. Experiment to learn in which order the glazes go on, and which colors work as glazes.

For both the underwash and the later glazes, use transparent colors. Likewise, don't glaze earth tones, because these colors are already mixes and become more muddy if you glaze over them.

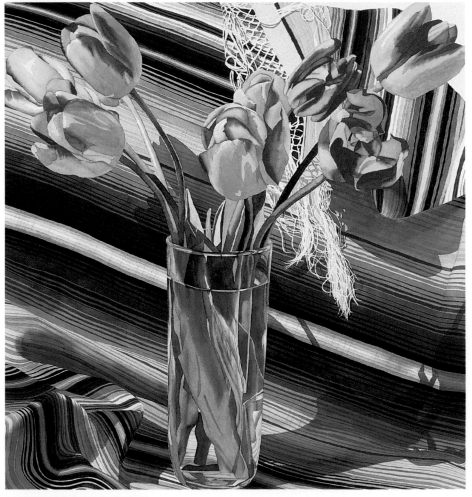

4 FINAL TOUCHES

After completing the serape, remove the tape from the inside of the vase, and apply new tape to the outside of the vase before completing the vase and stems. Remove the frisket and stroke on the remaining details. Winsor Red is the last color applied to the tulips, because touching it with a wet brush after it is dry would cause it to run amok! *Tulips and Rainbows* is now complete. Notice how the purple is no longer in evidence! What remains is a bold, vibrant painting of bright yellow and red tulips with a brilliantly colored serape. Strong and beautifully contoured shadows are the result of the purple underlayer. The purple shadows give the painting its power and exciting design, and yet the purple has disappeared.

TULIPS AND RAINBOWS
39″ × 38″ (99.1cm × 96.5cm)
Private collection.

Full Spectrum: Demonstration 2

1 BEGIN PAINTING VALUES

Use a no. 2 (soft) and no. 6 (hard) pencil to create your drawing on 300-lb. (640g/m²) rough watercolor paper. Use drafting tape to form crisp edges along the vase and tulip stems. Apply frisket to save small white areas. Lay in washes to describe the

folds of the fabric, using French Ultramarine with Permanent Rose for the pale shadows and French Ultramarine with Permanent Alizarin Crimson for darker shadows. Paint a medium to dark value early, so you have a value gauge. Take time to capture the shadows and reflected light with beautiful washes and edges.

2 DEFINE BACKGROUND SHADOWS

Continue to define shadows, establishing values and shapes with purple washes. Paint a full range of values from dark to light. Use a French Ultramarine/Permanent Alizarin Crimson mix for mid to dark values, and a French Ultramarine/Permanent

Rose mix for the lighter shadows. Use a cool mix (more French Ultramarine) to push the darkest deep shadows into the distance. Use a warm mix (more Permanent Rose or Permanent Alizarin Crimson) for the folds that come toward the viewer.

3 PAINT TULIP SHADOWS

Use Permanent Rose and French Ultramarine to paint warm, delicate shadows on the tulips; these shadows will show up under the yellow local color to come. The warm shadows pull the tulips toward the foreground. The larger tulip in the upper left, which is more in shadow, has a cooler purple shadow. Paint shadows with a graded wash to give petals softness. Paint the hard edges

darker and wash more water into the middle to give the shadows glow from the white paper.

4 ADD COLOR TO TULIPS

Use mixtures of Winsor Lemon, Winsor Yellow and New Gamboge to paint the yellow local color of the tulips. The petals do not all appear the same color, so vary the amounts of each color in the mixtures. Petals with the most intense yellow may need a touch of Cadmium Yellow or Cadmium Yellow Pale. Thin out the color where sunlight appears to wash out highlights. A

fluid wash is more interesting and realistic in the petals than a flat wash.

5 ADD COLOR TO SERAPE

Begin with a pale gold mix of Aureolin, Yellow Ochre and a whisper of Winsor Red. Paint this color from the lightest stripe across the next two darker stripes. Building up the color of the stripes from light to dark blends the transition between the stripes. When the first band of color is dry, paint the second stripe a mixture of Indian Yellow, Yellow Ochre and Winsor Red. Paint this color through the next two darker stripes. Let it dry. The third stripe is Winsor Yellow and Scarlet Lake. Paint this mix through two more darker stripes.

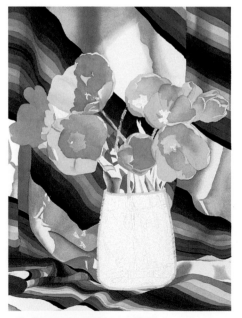

6 DEVELOP RED IN SERAPE

Paint the red stripe with Winsor Red, and continue painting this same color through where the burgundy stripe will fall. The shadows, as well as the white paper, still show up through the bands of local color. Paint the burgundy stripe with a mixture of Permanent Alizarin Crimson and a bit of French Ultramarine, painting it through the burgundy and into where the black stripes will fall.

7 ADD BLUE TO SERAPE

Paint the blue stripes, starting with a pale mixture of Winsor Blue (Green Shade) and Hooker's Green throughout the first three stripes. Let dry. The second blue is Winsor Blue (Green Shade), grayed with Burnt Umber. Paint this across the next stripe as well, and allow to dry. Paint the third stripe Cobalt Blue, grayed with Burnt Umber, through the fourth stripe. Shadows and white paper still show through the color.

8 FINISH THE STRIPES

Finish painting the blue stripes using Winsor Violet for the fourth blue stripe. For the black stripe next to the blue, mix Winsor Blue (Red Shade) and Permanent Alizarin Crimson with a little Ivory Black. For the black stripe next to the red, mix Permanent Alizarin Crimson, Ivory Black and a little French Ultramarine. Notice how the purple has disappeared, reading now as folds and twists in the serape.

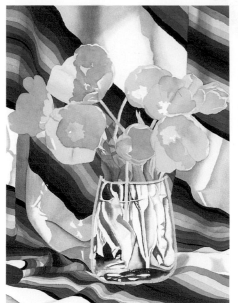

9 PAINT TULIP STEMS AND LEAVES

When the stripes of the serape are complete, remove the drafting tape on the inside of the vase and stems. Position new tape on the outside of the vase and stems. Paint shadows in the stems. Begin painting local color on tulip stems and leaves, using mixtures of Hooker's Green with Winsor Yellow and a trace of Winsor Red for a natural green.

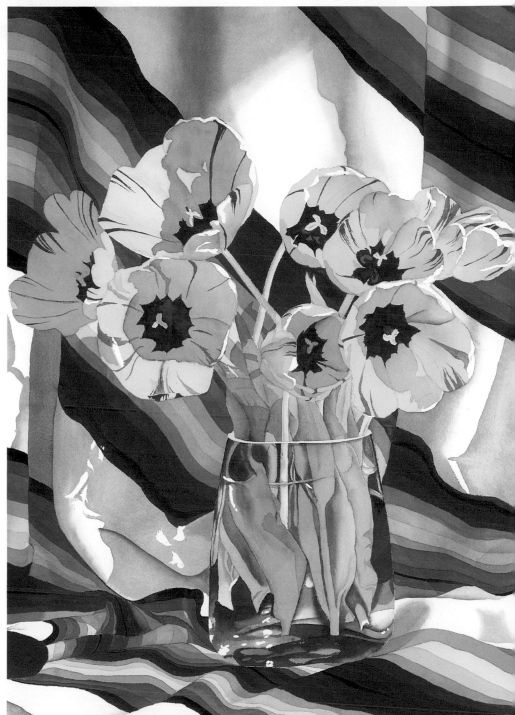

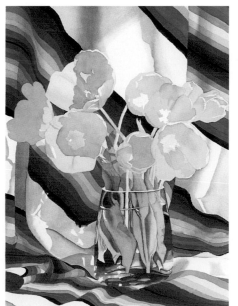

10 COMPLETE STEMS AND LEAVES

Complete painting the tulip stems and leaves. Paint the refracted stripes inside the vase. Remove the drafting tape. The colors are clear, sharp and brilliant.

11 ADD FINAL DETAILS

Remove the frisket and add details to the tulips, including thin red stripes of Winsor Red and Scarlet Lake on the petals. With a mixture of Permanent Alizarin Crimson, French Ultramarine and Ivory Black, paint the black pattern inside each blossom to complete *Full Spectrum*. By reserving the brightest, boldest (warmest) yellow for the largest center tulips, notice how they appear to lean toward the viewer; the cooler purple shadows help the serape recede into the background. Compared with step three, the purple has vanished. Yet the shadows give shape and structure to the bold, brilliantly colored stripes and sunny tulips.

FULL SPECTRUM
29½″×22″
(74.9cm×55.9cm)
Collection of the artist.

1. Use adjoining transparent colors, such as French Ultramarine Blue and Permanent Alizarin Crimson, to mix your purples so the white paper will glow through the color.

1. Paint purple shadows first to create a structure for your brilliant colors.

3. Paint the purple dark enough to show up under the glaze of local color.

4. Take time to paint delicate soft edges and crisp hard edges to emphasize shapes and contours.

5. Use your value scale to help you see and create a full range of purple shadows.

6. Vary the temperature of the purple, depending on local color and whether you want an area to come forward or recede.

7. Paint the local color with one stroke so you do not lift the underlying purple shadows. Let dry completely between layers.

8. Keep in mind that fewer colors mixed together result in clearer and more brilliant colors.

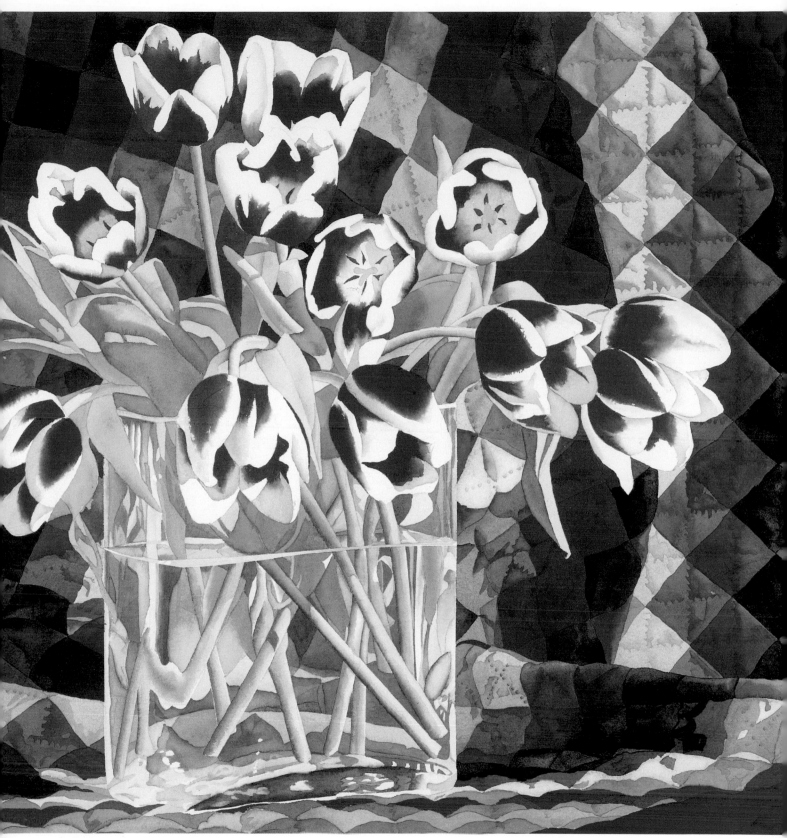

Purple Disappears Under Colors

A transparent mixture of French Ultramarine and Permanent Rose establishes the shadows and contours of the soft, puffy quilt texture. The purple shadows tend toward blue in the tulip leaves and toward rose in the red flowers. Painting quilt, flower and leaf colors over the shadows makes the purple disappear. Your eyes see the purple only as a muted shadow relative to the bright colors of the tulips.

STAR BRIGHT
28″ × 39″ (71.1cm × 99.1cm)
Collection of the artist.

Painting in Brilliant Color

AUTUMN GLORIES
28″ × 39½″ (71.1cm × 100.3cm)
Collection of the artist.

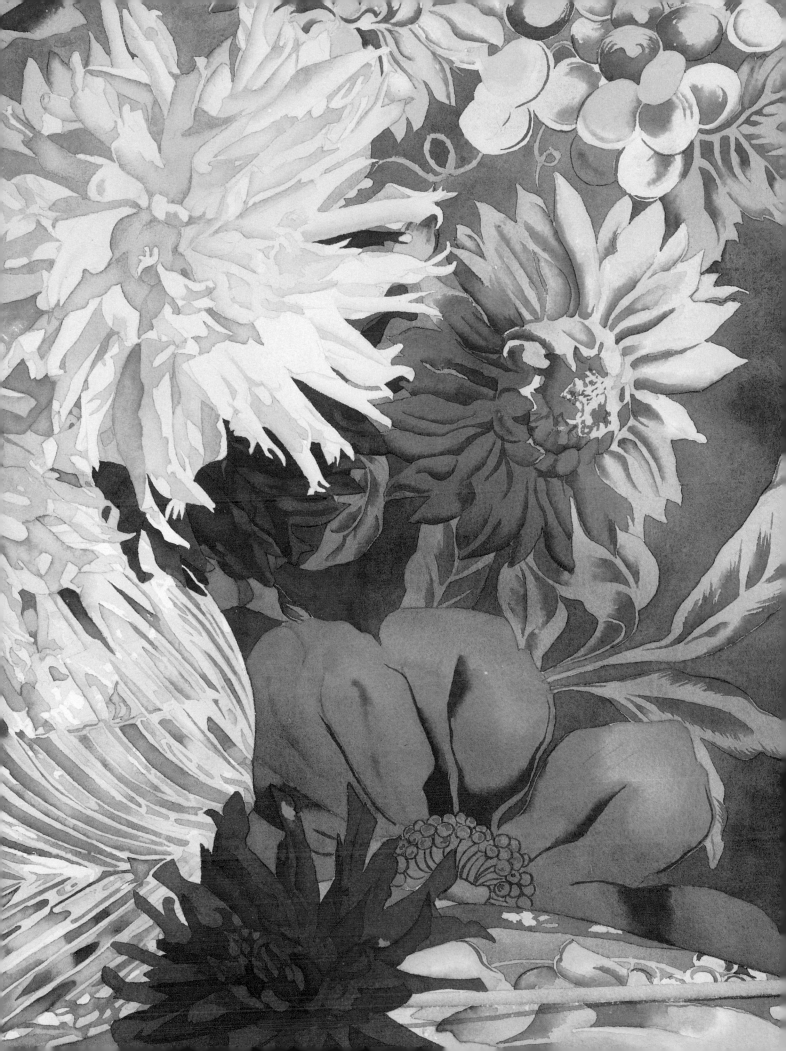

Put It Together Step-by-Step

The following step-by-step demonstration shows one of my paintings progressing from start to finish. I did this painting on 300-lb. (640g/m²) rough watercolor paper with Winsor & Newton artist-quality watercolors and Winsor & Newton series 7 sable brushes. This is a very complicated composition. For your own painting, you might want to start with a small section or simpler design first, and then increase the size and complexity as you master each skill. The steps of this demonstration are designed to show you the *planning*, *colors*, *techniques* and *value statements* I use to create brilliant watercolors, rather than showing you detailed instructions on how to create this particular painting.

When planning *your* painting, I encourage you to look before you leap. Study the subject and composition before you paint to assess the best way of presenting the subject and capitalizing on the special beauties of watercolor. Design your composition so the subject stands out against its background. Use juicy, transparent colors. Include a full range of light and dark values, hard and soft edges and flat and graded washes. Encourage happy accidents, and take advantage of the spontaneity of watercolor. Most importantly, while you are juggling all these different ideas and techniques, keep in mind the *big* picture: What is the purpose of your painting?

Studio Setup

Materials and equipment are handy, arranged within easy reach. The lamp has both fluorescent and incandescent bulbs for a light that imitates daylight and reduces eye strain. Students express surprise at the small glass water containers I use for my large paintings. Working with clean water helps keep colors pure and bright, and I prefer to dump and refill the glasses as frequently as needed. Glass makes it easy to monitor clarity of the water. Wash the brush out in one glass, and use the other, along with a spray bottle, to supply clear water.

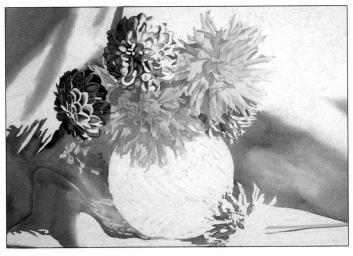

DRAWING TIP

Make your first drawing very lightly with a no. 2 pencil. When the placement is satisfactory, complete the drawing with a no. 6 (hard) pencil. Very gently erase the no. 2 pencil lines, taking care not to disturb the surface of the paper. Leaving the no. 2 drawing will muddy your paper, because the lead dissolves with your first washes. A no. 6 (hard) pencil lead does not dissolve with water.

1 DRAW STILL LIFE AND BEGIN SHADOWS

Sponge and stretch 555-lb.(640g/m²) 29½″×41″ (74.9cm×104.1cm) rough paper, staple it to a drawing board and let dry. Mask off a 1″ (25mm) border with drafting tape. Begin drawing the main subject with a no. 2 (soft) pencil. When the basic placement is satisfactory, make the final drawing with a no. 6 (hard) pencil. Add frisket to highlights (where sun hits petals) or where you want to hold the white paper (on cut glass edges).

Use series 7 brushes to paint the flowers' shadows with pale washes of a mixture of Permanent Rose and French Ultramarine. Use a warm tint (more Permanent Rose) for the center petals of the blossom and a cool tint (more French Ultramarine) for the outer petals. Establishing warm and cool this way gives depth and a three-dimensional, rounded shape to the blossom. It is important to make every wash beautiful. Do not daub around in it and muck it up. All these special efforts will shine through the final glaze of color.

2 ADD LOCAL COLOR TO FLOWERS

When the shadows are dry, brush on the warm gold of the dahlia petals. Use a mixture of Aureolin and Permanent Rose, ranging from rosy gold to brighter yellow at the blossom's center. Add a touch of Winsor Yellow to the mix for the center.

I like to begin with a difficult part of the painting. There is no point in investing a lot of time in the painting only to have it fail because of a problem with technique. Yellow flowers are troublesome to paint. There is no yellow that will make a dark value, so you must find a way to create strong shadows without all the colors turning a murky brown or gray. Painting the shadows first with pale reddish purple creates dynamic shadows that show up under glowing layers of yellow.

3 EMPHASIZE SUBJECT MATTER

Add more frisket to save whites on the background pattern as necessary. Drafting tape saves the white on the stem in the lower right.

Make sure your shadow values emphasize the subject matter. The subject must be a different value than its background. Paint the darkest shadows in the flower on the left, using a mix of Permanent Alizarin Crimson and French Ultramarine. The pale shadows in the yellow dahlia and this dark shadow are the two extremes against which to judge the remaining values. Remember to use your value scale to judge the values of your shadows.

Do not rush when painting the shadows. Use both flat and graded washes, making each wash as beautiful as possible. Paint clear water first to wash out the center of the shadow to the right of the vase and beside the vase's lower left side. Examine the still life closely to see hard and soft edges. Look for and exaggerate lovely shapes, like the lacy shadows of the dahlia on the left side. Push the pigment toward the edges to emphasize these shadows. Wet-into-wet edges show the soft folds of the background fabric. Painted hard edges make the vase stand out from the background.

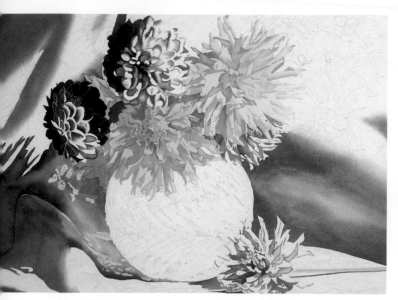

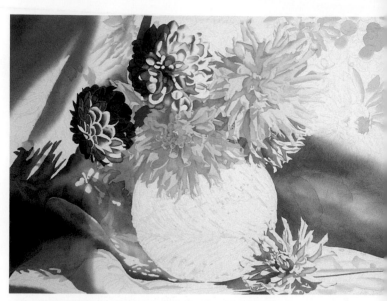

4 CREATE A FULL RANGE OF VALUES

Knowing the shadows will disappear under layers of local color, I darken the deep shadows, especially at the edges. It is very important to have a full range of values in the shadows. At this stage, it may appear that the shadows are too strong, but experience has taught me they will be about right in the finished painting.

5 ADD LOCAL COLOR TO BACKGROUND

Begin painting the local color from light to dark. Use only transparent colors to ensure the purple shadows shine through and do not turn to mud. Brush on the background fabric's gold color with a mixture of transparent Aureolin and Permanent Rose, mixing in New Gamboge where the gold is intense. Vary the amounts of these three colors to paint all the different gold hues throughout the painting.

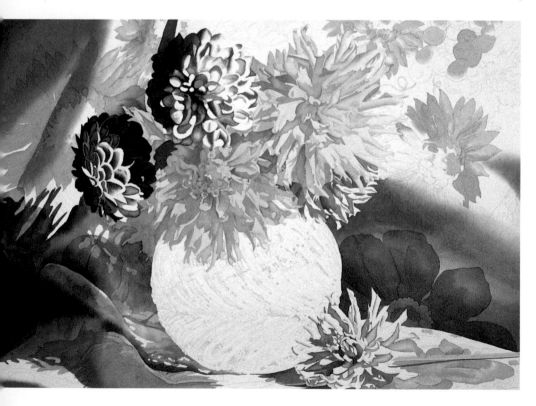

6 DEVELOP BACKGROUND COLORS

Add the pink hues of the background fabric. A little Winsor Red with a lot of water makes a lovely pink. Soft edges of pink blend into soft edges of gold, wet into wet. Hard edges of pink help define separate petals where needed, wet into dry. The transparent Winsor Red keeps the colors clear and bright over the purple shadows. Do not worry about pencil lines: Most will disappear into the details of the final painting.

7 BUILD DETAILS

Develop details in the background from light to dark, using glazes of transparent colors. Permanent Alizarin Crimson glazed over pink gives definition to the center of the blossom. Paint the first glaze of muted green leaves, a mixture of Hooker's Green, Yellow Ochre and a trace of Scarlet Lake.

8 DEVELOP DETAILS

Using a mixture of Permanent Alizarin Crimson and Winsor Violet, glaze another layer of detail over the pink-and-yellow background flowers. The underlying purple shadow shows through the center of the pink blossom, yet the transparent colors remain clean and radiant. A dramatic dark purple shadow effectively separates the foreground flower from the lighter background and shows special attention to both soft and hard edges. Paint details in the leaves with a glaze of dark green, a mixture of Winsor Green (Blue Shade) muted with Winsor Red.

9 PAINT THE GRAPES

The blue-gray grapes appear somewhat opaque, so paint them with a mixture of Cerulean Blue grayed with a touch of Burnt Umber. The dark green color on the grapes and in the details of the leaves is Viridian and Winsor Green (Blue Shade) muted with Winsor Red. When the grapes are finished, paint the accent lines with Permanent Alizarin Crimson and Winsor Violet.

10 COMPLETE BACKGROUND DETAILS

Complete all details in the background in preparation for a flat blue background wash. Shadows retain their power, even through all the layers of transparent glazes. Details show up and colors glow in the shadow areas as well. The crimson foreground flowers will be painted *after* the blue background, so the darker crimson color will not bleed into the lighter blue.

11 PAINT THE BLUE BACKGROUND

Paint the blue background in sections determined by breaks in the flower pattern (see sidebar, below, for details). Complete each section of blue and let it dry completely before going on to the next section. You do not want to smudge previously painted colors by accidentally touching them before they dry. Keep turning the painting so the leading edge of blue is downhill from the start of each section. Make sure the white paper glows through the blue.

MIX ENOUGH COLOR FOR EACH WASH

Since the blue background has body and substance, and because it is the last glaze, use a somewhat opaque color. Mix Cerulean Blue and Cobalt Blue with a touch of both Winsor Blue (Green Shade) and Quinacridone Magenta. Mix enough for the background of the whole painting. You do not want to have to mix more, because it would be difficult to match this color. Paint the blue as rapidly as possible to make a smooth wash without backwashes.

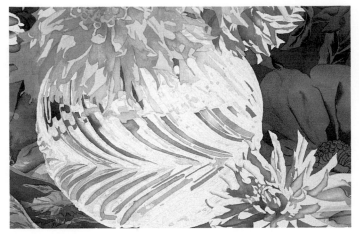

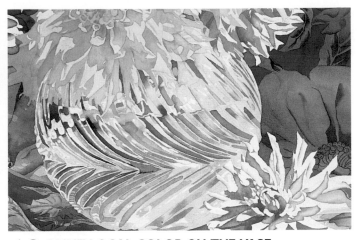

12 PAINT SHADOWS ON THE VASE

When the blue background is completely dry, begin creating the cut glass vase. Paint shadows with a mixture of Permanent Rose and French Ultramarine. For particularly dark shadows, use a mixture of Permanent Alizarin Crimson and French Ultramarine. Use more blue in areas where the local color is cool, like the greens and blues in the upper left part of the vase. Use more rose where the local color is warmer, like the center of the vase. Hard edges define each sliver of the cut glass pattern.

13 PAINT LOCAL COLOR ON THE VASE

Glaze on local color, painting from light to dark. Each stripe of the cut glass pattern has a hard outside edge with soft edges on the inside, where the reflected colors meld together. Watercolor is the perfect medium for capturing the interplay of reflections of water, stems and background. Look carefully at the reflections for clues on how to go wild with color—and play these for all they are worth! Exaggerate the intensity of the colors you use on the cut glass. Remember that colors that look bold and bright when wet will dry much paler.

14 ADD FINAL TOUCHES

Paint the remaining dark red dahlias with Permanent Alizarin Crimson. Add a little Winsor Red to make the color more vibrant. When the painting is dry, remove the frisket. Where needed, wash clear water just enough to soften the paint and relieve the stark whiteness of the paper, such as on the dark red blossoms.

Autumn Glories makes the most of the characteristics of watercolor. White paper shows through transparent colors. Flat and graded liquid washes of color shine with beauty. Water pushes pigment to form hard or soft edges.

The design of the painting works. The viewer's attention moves into and around the painting.

Part of the drama of *Autumn Glories* is the juxtaposition of opposites. The warm red-and-yellow dahlias leap away from the cool, blue background, making your eye jump back and forth from foreground to background. This dynamic painting sizzles with excitement!

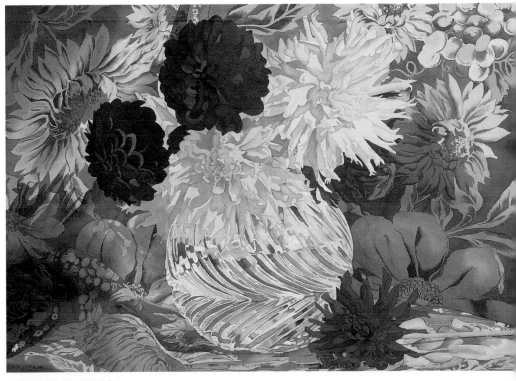

AUTUMN GLORIES
28″×39½″ (71.1cm×100.3cm)
Collection of artist.

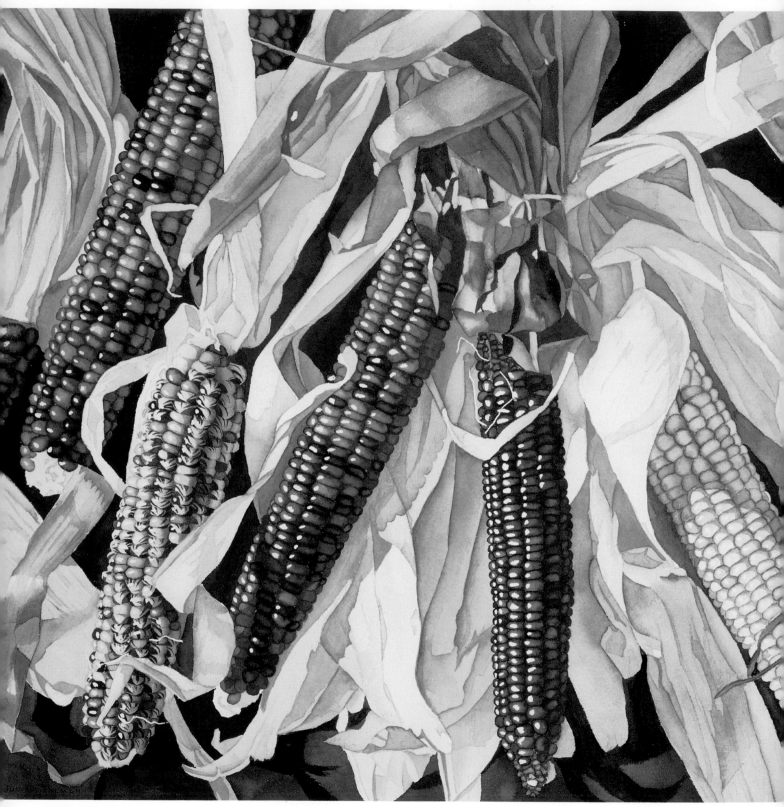

RED-HEADS
20″ × 28″ (50.8cm × 71.1cm)
Private collection.

Build Ever More Brilliant Watercolors

I am a crusader for building the respect watercolor deserves in the art world. I believe watercolors to be as sophisticated as oils or acrylics for realizing detail, as well as for deserving a lasting place in the history of art. I believe in using watercolor for major artworks, as a medium on par with oils in longevity and significance. Therefore, I encourage watercolorists to do their own quality control in respect to materials, technique and framing, to enhance the reputation of watercolor. That includes making sure that only your best paintings reach the exhibition wall or the collector. Do not be satisfied with less than your best.

Watercolor Takes Courage

Creating brilliant watercolor paintings is not for the faint of heart! Practically speaking, watercolor is an unforgiving medium, so you have one chance to paint it right. When you pick up the paintbrush, you need to leave your anxieties and worries behind and awaken yourself to explore new ways to create shimmering watercolors. It is my hope that this book will give you the tools and the courage to enhance your style through the use of brilliant watercolors.

Pushing the Limits

As a perfectionist, I always strive for excellence. Every day I work to create ever-larger, more complex and more colorful watercolors, always pushing the limits. I keep trying to use more and more color, until I reach the limit where the painting quits working. So far, it keeps working—and I keep pushing. Hopefully, the techniques in this book will also help you to push your limits.

Take a Risk and Find the Joy

Achieving a sublimely masterful work of art requires taking some risks. Greatness does not come from taking the safe road. Try something new. Experiment. Sometimes it works, and sometimes it does not. The worst that can happen is that you will learn from the failures. It is the *joy* of a successful spontaneous wash or a splash of bold color that is the reward and that keeps artists coming back for more!